THE WISE GIRL'S GUIDE TO FREELANCE MODELLING

THE WISE GIRL'S GUIDE TO FREELANCE MODELLING

The Dos and Don'ts of Becoming a Successful Freelance Model

LIZZIE BAYLISS

THAMES RIVER PRESS

The Wise Girl's Guide To Freelance Modelling
The dos and don'ts of becoming a successful freelance model

THAMES RIVER PRESS
An imprint of Wimbledon Publishing Company Limited (WPC)
Another imprint of WPC is Anthem Press (www.anthempress.com)
First published in the United Kingdom in 2014 by
THAMES RIVER PRESS
75–76 Blackfriars Road
London SE1 8HA

www.thamesriverpress.com

© Lizzie Bayliss 2014

All rights reserved. No part of this publication may be reproduced in any form or by any means without written permission of the publisher.

The moral rights of the author have been asserted in accordance with the Copyright, Designs and Patents Act 1988.

All the characters and events described in this novel are imaginary and any similarity with real people or events is purely coincidental.

A CIP record for this book is available from the British Library.

ISBN 978-1-78308-242-1

Printed in Malta by Melita Press

This title is also available as an eBook

Foreword

I am delighted to have this opportunity to write a foreword for Lizzie's book. No one in modelling is better qualified than Lizzie to advise not only models, but many photographers too, on how the business operates, and how we should relate to one another, as well as on how take to good photos.

Lizzie has come from being a nobody to being one of the leading freelance models in the UK in just three years. She does an average of six paid shoots a week – over three hundred a year – which is almost certainly more than any other independent UK model, and more than any agency model I know. Lizzie has it all: she's a perfect UK size 6–8 with an incredible hour-glass figure, gorgeous hair and eyes, and 'the cutest bum in Europe' (not my own words, but those of many other photographers!). But looks alone are not enough. She has an instinct for getting the pose right: the posture, the angle of her limbs and torso, the subtle tilting of her head, and the smouldering look in her eyes. She also has a lot of make-up and costume skills , and has national qualifications in both. I've worked with her on shoots in all weathers and conditions; some shoots lasted as long as twelve hours, and while the photographers were falling exhausted by the wayside, she stayed fresh and lively until the end.

Lizzie has something else which is very rare in a model: she *knows* about photography, in fact, she knows more about camera-settings, lighting, and Photoshop than most of the photographers she works with, and this always results in a very productive shoot. She even runs tutorials and masterclasses for photographers, which are very well attended. As she says in her various profiles, she *loves* what she does.

She has already done more at twenty than most models who are ten years older. Ask any photographer who knows her, and he will tell you that what is most appealing about her is how easy she is to work with, how she chats and jokes non-stop, how she's highly-intelligent yet modest without abasement, confident without cockiness, and how every single one of them wants to work with her again.

It must be galling for her, therefore, to come across so much ignorance and rudeness from a minority of people who approach her, many of whom aren't photographers, and she gives examples of these types in this book. She tells me that every single day she is fending off fakes and charlatans. So that's why she

decided the time had come to write it all down, to help other models, and to make the good guys in photography aware of just how bad the bad guys can be. There something in this book for everyone: the new model starting out, the established model who wants to get better, and the photographer who is interested in a model's perspective.

Soft-focus, international photographer
London, 2014

Caveat Lector

Most models are female and most photographers are male, so the 'she' pronoun is used for models, and the 'he' pronoun for photographers. The author apologises if this causes any offence. It must also be pointed out that the material in this book applies to freelance modelling in the UK, where the culture and methods may vary from those in other countries.

Thanks are due to the many photographers who kindly allowed me to use their work in this book. Credits appear under each image.

Index

1.	About me	1
PORTFOLIO 1: FASHION		3
2.	What sort of modelling should you do?	11
3.	Younger and older models	15
PORTFOLIO 2: BEAUTY		17
4.	Choosing a modelling website	27
5.	What do you put in your profile?	31
PORTFOLIO 3: COMMERCIAL		33
6.	How to manage your profile	41
7.	TFP/TFCD/Collaboration	43
PORTFOLIO 4: ALTERNATIVE AND RETRO		51
8.	How to arrange a shoot	61
9.	Shooting at home and away	63
PORTFOLIO 5: PARTS		67
10.	How to prepare for a shoot	75
11.	How to conduct yourself at a shoot	79
PORTFOLIO 6: LINGERIE		81
12.	How to pose	89
13.	Working with other models	93
PORTFOLIO 7: GLAMOUR		95
14.	After the shoot	103
15.	Types of photographers	105
PORTFOLIO 8: ARTISTIC NUDE		111
16.	Agencies	121
17.	Marketing	123
PORTFOLIO 9: EROTIC		125
18.	Conclusion	131
19.	Lizzie's tips	133
PORTFOLIO 10: PIN-UPS		135
	Links to Lizzie	145

1. About me

It was autumn 2010 when I first contemplated modelling. While chatting to friends on-line, where I had posted a few photos, I was often asked whether I had tried modelling. I hadn't, and wasn't sure how to get into it.

Then, someone offered to pay me if I modelled for him. He was a hobbyist photographer, and liked my enthusiasm. He sent me a link to websites where he had lots of feedback from models who had worked with him, and said I could bring a friend to the shoot if I liked. I was very reassured that he was so open and honest. I was a penniless student, and struggling to feed myself and buy college materials, so I jumped at the opportunity. The shoot went well. He gave me a dressing room to change in between sets, and kept stressing that I should only do what I felt comfortable doing. We kept stopping for tea, and he joked a lot. It put me at ease, and I began to relax and enjoy myself. I was surprised at how confident I felt and, at the end, he told me that I was easy to work with, and had potential. He showed me the photos he'd taken on his camera, and I was thrilled with the results. Even though he was paying me, he said I could use any of the photos I liked to start a portfolio, and he went on to suggest modelling websites where I could upload a profile. I think it helped me a lot that my first shoot was such a good experience, but sadly, that's not the case for all new models, as you will read later in this book.

I constructed my profile and uploaded some photos onto a modelling site, and very soon I started to get messages from other photographers. Most offered photos in exchange for my time, but some offered to pay me, so I stuck to those, and never needed to shoot without being paid. My college course, a national diploma in fashion design, left me with three free days a week, which I then dedicated to modelling. Those three days very quickly filled each week, and soon I found myself taking bookings a month or two in advance. I loved meeting new people, and found them all very encouraging. I was learning a lot at every shoot. In my early teens, I'd been quite shy with strangers, so the experience of doing shoots did wonders for my confidence. I felt like a different person – grown up, and with something to offer which people would pay me for doing, and it seemed to come naturally to me. Compliments flowed thick and fast, not just about my looks, but about my developing skills, and soon I found myself wanting also to learn more about everything to do with the

modelling world and photography. It has always been my aim in life to try to be the best in whatever I do.

Two years later, and I'm modelling full time, doing shoots almost every day, and even able to turn down those which I believe aren't economically worthwhile or artistically interesting. I've spent some of the money earned from modelling on photographic equipment – professional lights, accessories, backdrops, cameras, even a vintage Hasselblad camera – and I now have a separate profile on some modelling websites as a photographer. I'm even learning to develop and print photos using traditional film. Like every job, modelling has its disadvantages and annoyances, many of which I cover in this book. Obviously I'm still learning, but I feel a million miles away from the shy, awkward college girl I was three years ago. The main purpose of this book is to help other girls get the same success from modelling that I have enjoyed, and still enjoy.

Portfolio 1: Fashion

The origins of modern fashion modelling date back to 1853 in Paris, when Charles Frederick Worth asked his wife Mary to model the clothes he designed, and many other fashion houses followed suit. This is where the term 'house model' comes from and, in those days, models of all shapes and sizes were used, according to what designs were on show. Nowadays, agencies only employ very thin, tall, models for fashion work, but there is nothing stopping a freelance model of any shape or size from modelling fashion, and there is certainly a groundswell of opinion that larger girls should be used as models by fashion houses. Fashion modelling is very much about styling, and can refer to any garment, whether it is haute couture, daywear, evening wear, swimwear, and even latex. The focus is on the styling more than anything else, and a range of lighting styles can be used to emphasise the theme and the styling.

© Patrick Shiel

© Outofrespect

© Awkwright's Photography

© Outofrespect

© Outofrespect

© Darren Athersmith Photography

© Outofrespect

© Outofrespect

© Regardez Moi Photography

2. What sort of modelling should you do?

Hundreds of new models appear on the modelling websites every single week, and an equal number disappear, because they didn't get any work. No doubt you are reading this because your friends and family have often said 'With looks like yours, you should be a model', or maybe you've been pleasantly surprised that the ugly duckling you once were, has now grown into a beautiful swan, and you see models in magazines and think you could do that too... and why not?

You are *not* selling your body: I got into a heated discussion on a website recently with two photographers who dismissed modelling as 'superficial' and claimed it simply involved selling an attractive body to anyone wanting to buy it. I hasten to add that these guys were writing anonymously, and refused to give their true identities – how many girls would want to work for a photographer with that attitude? I pointed out that what the model is doing is not *selling* her body, but *exhibiting* it: the model is a performer, just like a dancer or an athlete. What the model is selling is the right for people to take photographs. In other words, models sell images not flesh.

Like it or not, however, most modelling is about sex appeal. Sex sells everything from cars to washing powder to garden tools. The female body is generally regarded as an object of beauty, whether or not it's being used to promote a product, so there will always be a demand for female models, despite the sneering feminist agenda which wants you to believe that that girls are coerced into modelling for the gratification of men. Most aren't, and most find the experience empowering: I did, and continue to do so.

Having said that, modelling almost always involves a degree of nudity, so if you are shy, you will *not* make it as a model. Some girls think that if they go for fashion, they won't need to do nude work, but even catwalk models wear see-thru or topless clothes on a regular basis, and find themselves having to change during shows with crowds of people standing around. So, even if you are lucky enough to be a very tall girl with that particular 'look' which the fashion houses want, don't expect to keep your clothes on. Kate Moss and Lily Cole, for example, have posed for many topless, nude, and see-thru editorials, and even the fashion designer Vivienne Westwood has posed for explicit nude shots, the

idea being that nudity is natural, normal, and very much part of modelling. So, even if you want to be a fashion model, don't be shy.

There is no doubt that girls offering nude shoots get more work. A photographer-friend of mine once said that a model unwilling to go nude is like a pianist who doesn't play all the keys: the music sounds awful. Your body is your professional tool, and it's what the photographers want to see and to photograph: so, unless you are willing to work at least up to implied nude, topless, or preferably full nude, many won't be interested. You need to rid yourself of any inhibitions if you really want to make it as a model. If your body isn't good enough for nude work, then it probably isn't good enough for clothed modelling either. I feel just as comfortable modelling with clothes on or off and, for that reason, I charge exactly to same hourly rate for all shoots up to and including artistic nude.

I've mentioned fashion, but for those of us too short for catwalk, there are lots of other types of modelling, including, pin-up, retro, fetish, glamour, alternative, commercial, parts, and lingerie, but before I describe those, let me finish talking about nude modelling by providing a glossary of terms, because misunderstandings about what is meant can lead to awkward moments.

Artistic nude is *not* adult. Although you are nude, the photographer won't be pointing his camera between your legs, and the market for this type of work is completely different to the adult market. It is mostly done by serious amateurs who care about their art, and who aim for high technical and artistic standards. Most artistic nude is beautiful, hence its name, and it seeks to glorify and celebrate the human form. It does *not* aim to sexually titillate. If a photographer books you for artistic nude, but then asks you to adopt poses which show your genitalia, you either need to ask him to stop, or charge a higher rate, if that is a level you are happy doing. Photographers who do that deliberately are what is called 'level-pushers'. If you suspect that he has put himself into shooting positions to push the level up in this way, make sure to keep an eye on what he then publishes, because if any of the photos show genitalia, then they are not artistic nude, they are *erotic nude*, which falls into the 'UK Mag' category. Most artistic nude photographers certainly don't try to push the levels, and even when this happens by mistake with one or two photos, they are more than happy to delete them.

Obviously, nude work is not for everyone, but you need to understand the terms people use when they write to you: 'UK Mag', involves open-leg shots but it varies in scope from 'Playboy nude' which attempts to do it tastefully, to the cruder manifestations which leave nothing to the imagination – usually garishly-lit, over-finished, and intended for the 'top shelf'. 'US Mag' is a level still higher, and is not only open leg, but you also show the 'pink' bits. It's what I call 'biological'! Then there is 'Continental', which is US mag with toys. For

these levels, the photographers often want to shoot videos too. The professional sells them as sets of stills and videos to websites which specialise in that type of material. Even though you are doing this as a solo performer, you may find yourself pictured on websites next to couples who are copulating, and people who Google you and see these pictures may jump to the wrong conclusion about the type of work you do, so you need to be aware of that possibility. You may also be asked for soft 'girl/girl', which is up to nude with another female model, but no sexual touching, or 'hard girl/girl', which includes sexual touching. 'Boy/girl' is self-explanatory, but most of the modelling sites ban any mention of this, because it is considered to be outside the scope of normal modelling. It is pornography, although everyone seems to have their own idea about what is pornography and what isn't. The saying goes that one person's erotic art is another person's pornography.

Just to confuse matters more there are also genres called 'glamour nude', 'fashion nude' and 'implied nude'. With so many labels, it's not surprising that there is often confusion about what is meant, so it's important to clarify this with the photographer *before* the shoot so that there is no misunderstanding. Whatever happens, *never* be persuaded to go above a level with which you are not entirely comfortable. A good photographer would never expect that from you, and most will check with you during the shoot that you continue to be happy.

If your boyfriend has a problem about you taking off a few clothes in front of a camera, then maybe it's time to change boyfriends – you're not compatible, and he's too immature or too jealous! It's not so easy with mums and dads because they are conditioned to worry about you and prevent you from getting into trouble, so try talking it through with them, and get them on your side. Let them know where you are going, and who you're going with, so that they feel reassured. Call them when you arrive at a shoot, and again when you're ready to leave. Whether you tell them everything about what you are doing is obviously up to you – you're over eighteen, after all, an adult, and it's your body, so you can do what you like; but there may come a time when you will need the support and help of your parents, so it's best to keep them onside if you can. Parents, especially dads, often don't like the idea of daughters stripping for photographers, but once the daughter starts to be successful, the parents usually shelve their reservations, and are very proud.

3. Younger and older models

The modelling industry is hard enough for adults, but even harder if you are under the age of eighteen. Models under sixteen can apply to agencies which recruit pretty, intelligent, and well-behaved young people for commercial and catalogue work. Girls and guys who are very tall for their age at fourteen or fifteen can send unedited photographs to fashion agencies and, if they are interested, they will interview them when they're are old enough. None of these agencies will sign up a child model without parental consent, and usually want parental presence at the signing.

If you are over sixteen some modelling sites will allow you to register and upload a portfolio. Until 2003 models over the age of sixteen could pose for nude photos, but then Parliament raised the age to eighteen, and now photographers are extremely cautious about a model's age. Many of them won't work with models under the age of eighteen simply because they can't risk the possibility of being reported for inappropriate conduct, which could include taking photos which might be construed as too 'sexy', even where no nudity is involved. So don't be surprised if most photographers ask you to get in touch again once you've passed eighteen.

For this reason, it is advisable for an underage model always to be accompanied by a chaperone – this is for the benefit of both the model and the photographer. Areas of interest for the younger model include fashion, dance, lingerie, beauty, hair, lifestyle, commercial and swimwear modelling. Despite the hurdles, young models can still be successful, and any experience you get when you are younger will help you in the future, even if your modelling career doesn't get going until you are older.

Most commercial and fashion agencies have a section called 'classic' modelling which involves attractive middle aged and mature women and men who have good skin, teeth and hair, and are available for commercial, catalogue and fashion modelling, but only the favoured few are taken on by the agencies, and the amount of work on offer is very limited. The best chance of getting regular work if you are a mature model is with freelance photographers who specialise in adult modelling.

Portfolio 2: Beauty

Beauty modelling is about portraying a fresh, clean look which focuses on the make-up and face of the model. It is important to try to keep your skin as clear as possible, to minimise the editing work for the photographer. If you have a poor complexion, this type of work is probably not for you. Beauty will normally involve natural or artistic make-up looks shot in a studio or location, and the focus is on the skin, facial features and expression, so good make-up application is key. A lot of beauty modelling involves interesting, eye-catching, artistic, and unusual make-up styles which could be for a commercial or lifestyle client. If you have nice hair which you're happy to have styled or cut to match the client's specifications, then you may want to look at hair modelling too.

© Floragraphy

© Stuart Rouse Photography

© Outofrespect

© Outofrespect

© Colin Nash

© Outofrespect

© Outofrespect

© Outofrespect

© Outofrespect

© Paul Bartholomew

© Floragraphy

4. Choosing a modelling website

There are lots of modelling websites where you can upload a profile, so I will now give you a run-down of the main ones, to help you choose. I have profiles on most of them. They all offer a free membership provided you adhere to certain restrictions, but have various grades of paid memberships for those wanting to have unlimited use of the facilities. It's certainly worth upgrading on at least one of these sites if you are serious about getting lots of work. If you are a tax-payer, the subscription is tax-deductible, as is the cost of this book!

Purple Port (www.purpleport.com): This is a relative newcomer to the scene, but in a very short time has leapt over the shoulders of its rivals and is now widely-regarded as the best in the UK. It certainly seems to get the most traffic, and my inbox from Purple Port is spilling over every day. The site is very easy to navigate, it's well-managed by nice people, and it offers all sorts of functions which other sites don't have. It allows members to communicate on a number of levels by 'liking' or 'tagging' photos, by listing people you'd like to work with, as well as by conventional messages.

Madcow (www.madcowmodels.co.uk): This is another websites that has grown very fast in recent years and, at the time of writing, is probably second to Purple Port in popularity. It has all the usual functions, and even allows people to comment on the casting calls which are put up – quite a useful idea, considering that many of the casting calls don't contain sufficient detail (see the section below on casting calls).

Purestorm (www.purestorm.com): This site used to be the market leader, but has lost ground to Purple Port and many of the smaller sites. The layout is very attractive, and the navigation is easy and well-presented, but there are fewer functions than on Purple Port. Countless numbers of good models and photographers complain that they have been banned from the Purestorm site without reason, and others, with very good track records, have had their applications to join the site rejected, again without reason. At the same time, the site continues to host the profiles of fakes, charlatans, and sex pests, including those in the adult 'entertainment' industry who have nothing to do with photography. Purestorm has failed to respond to representations about its

selection and banning policy, both directly, and by public campaigns on sites like Facebook. For this reason, I am no longer able to recommend Purestorm as a site worth joining.

Model Mayhem (www.modelmayhem.com): This is a US site with a large UK membership. It's a well-organised site, easy to use, and very popular, but the main drawback is that, unlike Purple Port and Purestorm, users cannot leave one another feedback after shoots, which I think is crucial to the promotion of careers, as well as providing a safety check for models to find out about photographers before agreeing to a shoot. It also has a befriending system, which is pretty meaningless. It's a modelling/photographic site, not a friendship site! When someone befriends me, provided they are based in the UK, I respond by asking if they would like to book a shoot, and occasionally, have been told 'No, I just want to be your friend', which is not the purpose of my presence on the website.

Net Portfolio (http://www.net-portfolio.co.uk): This is a nice site with lots of little gimmicks and a good layout but no one uses it! In the last year I've only received eleven messages. Compare that with several hundred a week I get from the other sites, and you'll realise that it's really not worth joining Net Portfolio, and certainly not worth upgrading to paid membership.

Net Model (http://www.net-model.com): This is a bit busier than Net Portfolio. I've had sixty messages in the last year, but since most of the photographers are also on the main sites, it's a bit pointless. This site has one really annoying feature: you can't see the thread of previous messages when you read or reply, and can only see the last message if the person writing presses the 'quote' option. It means you have to keep going backwards and forwards from the sent box to the in box to remind yourself what's been said previously. Very cumbersome. I've raised this with the webmaster, but had no reply. Unresponsive sites just aren't worth the effort.

Portfora (http://portfora.com/) This new arrival on the scene is based in Canada, but is seeking members in all countries, and aims to be a high-class site which discourages any mention of adult work, and prefers to have serious models and photographers among its members, rather than GWC's (guys with cameras) or hobbyist models.

Other sites spring up from time to time, but never last, or are scams in the first place. Don't bother with the ones that are exclusively used by US photographers and models (unless you plan going there) because you'll be wasting your time. My recommendation for anyone wanting a good, busy, site is Purple Port or Madcow.

There are a few "general problems" with these websites – I have listed the most common below, so you will know what to do if anything comes up!

Dictatorships: one of the site owners recently said to me that he ran the site as a dictatorship, not a democracy, and that seems to be the case with all websites: that they have their own rules, some of which may seem very silly and petty, but if you don't adhere to them, you will get thrown off.

Casting Calls: adverts for modelling jobs are called 'casting calls', which is actually a misnomer, because they are very rarely about casting – i.e. selection by audition – but are simply job adverts, paid or not. While a few photographers take the trouble to describe very clearly what they are looking for in their advert, the vast majority give almost no information at all, especially about the amount of payment on offer, so it is then down to the model to exchange a series of emails to find out whether or not the job actually suits her. Many photographers putting up these casting calls don't even have the courtesy to respond to enquiries or applications, so a lot of time is wasted all round. If only they would spell out exactly what they want and how much they are paying, then models wouldn't waste time applying for unsuitable jobs, and photographers might then have time to respond to those who actually apply, if only to say 'thanks but no-thanks'! Casting calls which involve no payment are called 'collaboration castings', and I deal with that subject later in the 'TFP/TFCD Collaboration' section.

'Work-safe' photos: most of the sites have rules regarding 'work-safe' photos, meaning that there are restrictions about how and where you can put photos which show nudity. The worry is that people who access the modelling site while at work might get into trouble if they open nude photos, so they have the option to turn on the 'work-safe' function. It seems to me that if someone chooses to go onto a modelling site while at work, then the risk is theirs, and I don't really understand why they need protecting, but my gripe with two of the sites has been about what exactly constitutes 'work-safe'. For example, even though you can go to a public beach and see thong bikinis which fail to cover the buttocks, two of the modelling sites have declared buttocks to be nudity. Is the buttock genitalia? No. Is it an organ for feeding infants? No. It's just the gluteus maximus muscle, covered by a layer of fat and skin. I should have thought that if a photo is of the type to appear in a Sunday family magazine, where adverts often show implied nude or see-thru clothes (and buttocks!), then they would be OK for a modelling site, but that isn't the case, apparently.

Recently, one of the sites suddenly declared that twelve of my photos, all of which had been on the site for ages, weren't work-safe. None of these photos involved any nudity at all (not even a naked buttock!), and three were head-and-shoulders shots. The photographer of one of these photos (shown below) wrote to the site to ask why his photo of me had been declared unsafe, given that it was a waist-up shot, and contained no nudity. He was told that it was 'just too sexy'. I suppose I should be flattered that the site thinks my face is so sexy that it must be hidden from the general public, but the photographer was

less amused. He suggested that only the Taliban would have found that shot offensive, presumably because it showed a naked face, instead of one covered by a burka!

© Outofrespect

But these rules are really not worth getting into a tizzy about, no matter how daft they may seem. It's far more important to keep the webmasters sweet so that the sites continue to get you business.

5. What do you put in your profile?

Don't lie about your stats: each website has its own layout for uploading your profile, which enables you to put in basic information like your age and measurements. It's *vital* that you don't lie about your measurements because if you turn up to a shoot and the photographer was expecting you to be 5'6" and size 6, but you're 5'2" and size 12, he will rightly show you the door. Mention any tattoos and piercings – some photographers hate them, but they are fine for things like alternative and fetish shoots. Also declare any large scars or birth marks you might have. Telling the truth at the outset might not lose you any work, but concealing the truth certainly will. Mention also the levels (topless, art nude etc) you are comfortable doing.

Check your spelling and grammar: there is also usually space for you to say a little more about yourself. Take your time with this. Put yourself in the position of someone reading your profile, and try to see how you come across. Make sure there are no spelling or grammar mistakes – you don't want to appear stupid or uneducated. If you're not quite sure what to say, look at some other profiles. On mine, I stress that I am professional in attitude – punctual, efficient, hard-working etc., and that I try to give good value for money. This is what someone who is going to pay you wants to know. They won't book you if they think you are sloppy and disorganised, no matter how pretty you are.

Quote your rates: you might wish to mention your rates and whether you give discounts for half or whole days – most models do – so decide what you want to charge for each level. Again, look around to see what others are charging. You can see my rates if you go to my website: www.lizziebayliss.co.uk. Also mention whether you would expect to get travelling expenses for away shoots, or whether you'd need to charge for a whole day if the shoot is a very long way from your home. For example, if you are asked for a four hour shoot (half a day) but the journey is three hours each way, added to which you need time for getting ready, you end up doing an eleven or twelve hour day for only four hours' pay, and you'll probably be too shattered the next morning to feel up for another shoot. If you are not very busy, this may be acceptable, but if you are turning away more lucrative home shoots, which take less out of you, then you

might think twice about accepting a shoot far from your home unless you are being paid for the full day. Most photographers I've met are sympathetic to this, and will either pay extra, or cooperate with other local photographers to enable you to do other shoots in the same areas, probably staying overnight to make it worthwhile. Some photographers decide that it's cheaper to come to you rather than ask you to go to them.

Take some truthful photos: however, the most important thing on your profile are your photos: upload some good photos, because no one will look at a profile which doesn't have them. To start with, it doesn't matter how technically good the photos are – you can even take them with your phone, with the help of a friend, or even using a mirror (no duck-face), but make sure they show your face clearly from front and side views, and also several different views of your figure.

Keep the camera low: if a friend is taking your photos, tell them to take full length photos holding the camera at waist height or lower because this shows your body in proper proportion. If a tall friend takes a photo of you looking downwards, it will make you look very short! It's good to have a headshot or two, and a full length in a bikini or lingerie, even if you only want to shoot fashion, because a photographer wants to see your true body shape before booking. It can also help to establish which styles of clothing suit you. Once you've had a few shoots, you can start to add better photos. If you do any 'collaboration' or 'TF' shoots, the photographers will give you a selection of fully-finished photos. Even for paid shoots, most photographers are happy to hand over a few, but make sure you give credit to the photographer when you upload the photos onto your profile.

Don't just sit back: within minutes of putting up your first profile, you will almost certainly get a lot of messages... to start with! But they soon die away, unless you are serious about wanting to model and have a business-like manner. It's no good just expecting the work to come to you – it won't. Being a model involves a *lot* of self-promotion and marketing. Looking good is just a starting point – you also need good computer skills, to be well-organised, literate, hard-working, punctual, full of energy, and ambitious. If you don't have those qualities, then you might as well give up before you start, because modelling is fiercely competitive, and only a tiny fraction of new models who arrive on the websites are still doing it six months down the line.

Portfolio 3: Commercial

Commercial modelling involves posing for advertising or lifestyle images, which often focus on the product or a natural environment. The model can be asked to pose in normal clothing or in lingerie, or with commercial products. It can also involve posing for 'stock' images. Most commercial modelling requires natural and relaxed poses, with the model looking relaxed and happy. For stock photos, she may be asked to portray emotions like euphoria, frustration, or worry.

© Gary Jenkins for Retro and Lace

© Outofrespect

© Dean Blowers

© Outofrespect

© Outofrespect

© Iridium Photographics

© Outofrespect

© Outofrespect

© KB Photographic

6. How to manage your profile

Being pro-active: you really need to check your profile every single day, even many times a day, if possible. Photographers will soon lose interest in you if you don't reply promptly. Most modelling sites have a reply rate which tells people how often you reply to initial messages. You need to be proactive. All the sites have several means of communication, other than messages. These include friendship requests, photo comments, listings, taggings, lovings, and followings, and you usually get notification by email when someone has communicated in this way. I *always* respond to these, even though they are not direct forms of communication. If someone comments on one of my photos, lists it, asks me to be a friend, or 'follows' me, I write immediately to the photographer, thanking him for his interest, and asking if he would like to book a shoot. It's called marketing yourself. It's not exactly cold-calling, because he made the initial move, but it's the way to generate business. More often than not, he will reply, saying he'd like to book you, or will book you when he has the cash, or is next in your area. This is how I get most of my work.

Good coms: in many of my references, photographers praise me for my good 'coms' meaning that the stuff I wrote was clear, efficient, and thorough. Get into the habit of replying to everything promptly, and establish a system of setting up a shoot. It should be achievable in the space of three or four emails. I start by sending my rates and availability. Once a date has been agreed, I send my address and phone number if it's a home shoot, or ask for the full address if it's away. I then ask for the photographer's phone too, and details of what he'd like regarding hair/make-up/wardrobe. A week before the shoot, I re-confirm by text, and make sure I get a reply. If a photographer who is coming to you is someone new, and doesn't have references on a modelling site, it's a good idea to ask for his full name and address when you send him yours. This deters fakes and sex pests, who might have the wrong idea, or hope that they are coming for more than photography.

Casting calls: another way of getting people interested in you, is to put up your own casting calls. Using these, you can tell people you are available on

a certain date or time, and say what you are offering, and for how much. The casting calls arrive in the email boxes of photographers who may not have noticed you before, so they draw attention to your profile.

The trouble is that casting calls don't always work, because so many models use them that photographers just don't bother to read them, and they get deleted without being opened. So I always follow up the posting of casting calls by emailing potential customers. If I'm touring in a certain area (see 'Tours', below), I do a search of photographers within a radius of the tour location, and email them the details of what I am planning. I always check that I haven't had previous correspondance so as to make sure the email doesn't sound impersonal, and I take care to head the email with the person's name to make it a little less like spam, which it is, of course. Most photographers either reply saying they are interested (and didn't see the casting call!), or say they can't make that tour but would like to book me on another occasion, so it's good advertising anyway. Others just ignore it, but a tiny minority complain that they don't like to be spammed. I apologise, but suggest that if they don't like spam, then it's best just to delete it.

Tours: 'If the mountain won't come to Mohammed, Mohammed must go to the Mountain' goes the old saying, meaning that you sometimes need to get out there and make yourself available, not expect the work to come to you. Doing tours is a good way of achieving this. Lots of photographers don't like having to travel far, and many don't have their own home studios, so if you can organise soemthing in their area, they are more likely to show interest. My early tours consisted of me going to an area and staying in hotels or B&Bs. I would either go to the local photographers' homes, or they'd come to me in the hotel. If the hotel wasn't suitable for a shoot (and most B&Bsare certainly not), then I'd be shooting outdoors on location, or at a local studio. On one occasion, this meant shooting art nude on Bodmin Moor in freezing conditions! These B&B tours were fun, but they were very hard work, involving a lot of travelling, and staying in different places every night. It was tiring, and once I'd paid for the accommodation and the travel, I barely made any profit at all, although some of the guys who shot me booked more shoots at later dates, so that made it worthwhile. Now I do it differently. I hire a holiday cottage or city apartment for a week or ten days, and make sure it is suitable for shoots, then the photographers come to me. I've done four of these 'cottage/apartment shoots' at the time of writing, and all were sold out, and a huge success. The photographers were all very appreciative, and many wanted to book me again, this time, coming to my home studio. I will talk a little more about how to organise a tour in the section 'Shooting at home and away'.

7. TFP/TFCD/Collaboration

In the following paragraphs I will talk about the various underhand methods employed by *some* photographers to get you to work for nothing. When parts of this book were serialised on an American modelling website, this section came in for a lot of criticism from photographers who don't or won't pay models. They clearly didn't like the idea that their devious methods were being exposed, and that I was advising models to be aware of the games they play to get something for nothing. Most serious photographers respect models, and are happy to pay (as long as the model is good enough), but many don't. I have some sympathy for those who can't, but none for those who won't. I'm not saying that all photographers who expect to shoot for nothing are necessarily bad guys, but you need to exercise caution because it's well-known that the world of photography attracts a lot of con-men, many of whom are definitely *NOT* interested in photography. I do not mean or intend to insult genuine photographers in this section, regardless of whether they pay models, so if you are a photographer reading this, and your conscience is clear, then fine, but please be aware of what the rogues are up to by reading on.

From the moment you post your first modelling profile on line, you will be inundated with requests from photographers wanting to shoot you for nothing, and you'll also see 'collaboration castings', saying much the same thing. For someone new to the scene, it's very flattering to get all this attention, and you'll think it's an honour to be asked. *It isn't.* You've probably always wanted to model, and here you are, minutes after putting your first profile online, and you think you are getting lots of offers, and that you're going to be famous.

GWCs: What you need to understand right from the start is that anyone with a digital camera these days can claim to be a photographer. Many aren't, and never will be. In fact, a 'Guy With a Camera' (GWC) is a well-known term which you'll often hear. It refers to someone who isn't really a photographer, but just a guy who is using a camera to get on his own with a pretty girl. Having said that, many 'GWCs' are nice enough chaps, and actually do try hard to take good photos, so don't turn down work offers from guys who don't have anything of quality in their ports – they might be just beginning. So long as they are polite,

efficient, and pay you for your time, it really doesn't matter to you how good their photography is, or what they do with the images after the shoot, unless it's a 'TF' shoot.

TF: 'TFP' or 'TFCD' means 'Time For prints' or 'Time For CDs' – in fact it's almost always CDs these days (or even emailed photos), because hardly anyone gives out prints, so it's usually shortened to 'TF'. So TF means you give your time for a shoot, and the photographer gives you pictures in return. 'Collaboration' usually means the same. When you are first starting out, you might need to do TF shoots, and will gain good experience from doing so, but once you have a reasonable portfolio, there really is no need, except for offers from photographers whose work is so outstanding that it would benefit your portfolio. Many of the photographers asking for 'free' shoots are beginners, or have nothing of quality in their portfolios. No girl in her right mind should be giving up her time in exchange for photos which are little better than holiday snaps taken on a phone. Some of these photographers make the photos even worse by their clueless attempts at Photoshop. So TF is bartering, meaning, you give me something I want, in exchange for something you want. In any barter, it's up to both sides to make sure what they are getting is of sufficient quality to make the swap worthwhile, so check carefully to see what is on offer: is his work good enough, how many photos is he offering, and what is the timescale for getting them? If you're satisfied with the deal, then fine, go ahead, but bear in mind that most photographers offering you paid shoots will also be more than happy to give you some of their photos for *nothing*! What they get from that is to see their work on a model's portfolio, duly accredited. More people tend to look at models' portfolios than at photographers', so it's good advertising for them.

Free commercial shoots: Many of the TF shoots advertised in the casting calls are for commercial organisations with wording like: 'My friend runs a shop so we need a model to shoot some advertising material' etc. Not only is the photographer getting your time for nothing, so is the company, which should really have an advertising budget to pay you. It simply isn't right that commercial organisations should use models for their marketing campaign, yet pay nothing, so *NEVER* apply for an unpaid shoot which is benefiting a commercial organisation – you are doing yourself, or another model, out of paid work.

I saw one advert recently, posted by a wedding photographer, which involved florists, cake makers, costume designers, and an expensive venue. The model was expected to work for nothing. When I asked the photographer about it, he tried to pretend that all the professionals there would also be giving their time for nothing – doing it for love, he said. Who was he trying to kid? How many florists provide flowers for nothing? How many wedding cake makers make

cakes for nothing? And do you really need photos for your port which make you look like the fairy on top of the Christmas tree?

I saw another one in which the photographer wanted a model to work for nothing on a project which was in aid of a charity. Again, money was involved, but the model was expected to work for nothing. It pulls on the heartstrings, doesn't it, to be asked to work for nothing in aid of a charity, but hang on, just because the photographer's favourite charity is the local dogs' home, does it need to be yours too? All charity events have budgets, and it's the *profit* that goes to the charity. It's not up to the model to increase that profit by working for nothing and, in any case, who is to know what is going into the photographer's back pocket? Don't be a mug!

Name-dropping: always avoid the photographers who pretend to have power or influence. These guys make false promises, like 'work for me for nothing and I will introduce you to...' and 'I have worked for this company or that company', or 'I have shot Naomi Campbell and Kate Moss', or 'I'm a talent scout for...' etc. It's all name-dropping bullshit.

Also avoid the ones who insist on meeting you for an 'interview' over coffee before they will give you a TF shoot. It's a power game. They like to pretend to be important and influential, and promise the earth. Sadly, a lot of girls fall for it. These guys are just pond-life, only one step up the ladder from guys who groom young girls for sex – in fact that's what some are after, so don't be taken by their slimy talk.

The following story is a true one – I met and talked to the girl in question. You may think it's an extreme example, but it's the sort of things that happens all the time.

Charlene was eighteen, and a pretty girl – slim, shapely, big eyes, and lovely hair. Ever since she became a teenager people had told her she ought to be a model. But she didn't know how to go about it. She lacked confidence, and came from a home where her parents were disinterested, and never seemed to have time for her. She left school at sixteen and drifted through a few boring and repetitive factory jobs where she felt even less valued than at home. Her boyfriend wasn't much help, either. Most weekends he was either playing football or getting drunk, and she even suspected he was seeing other girls. So, like most teenage girls, Charlene turned to the Internet for friends and advice. On one social network site she met a man who said he was a photographer, and did commissions for some top international fashion brands. Charlene was impressed, and soon found herself agreeing to travel two hundred miles to shoot with him. When she got there, she was diappointed and surprised to find the shoot was to take place in a very seedy and small flat, but believed the photographer when he told her he'd borrowed the flat while his studio was being re-decorated. She was also surpised that he had only one small camera, and no lights, but this was only a 'test' shoot, he explained, and if she passed the test, she would have many

shoots at posh studios in London and would feature in marketing campaigns all over the world. She was dazzled. No one had ever given her this sort of hope before. Her life was about to change. Although a little shy, she gladly took off her clothes for this man, a man who was going to change her future, and she smiled nervously when he asked her to open her legs, and move very close to the camera. He was going to make her rich and famous, he kept saying, so maybe she'd like to show her gratitude. It was what all models did, he assured her...

On her way back home, she wished he'd used a condom and hoped there would be no unwanted consequences. Obviously, she wouldn't tell her boyfriend what had happened. After all, wasn't it what all models did if they wanted to be successful and famous? That's what the man had told her.

She waited a few weeks, hoping every day to be called to London, but it never happened. Eventually, she started sending messages to the man. At first, he ignored her, but eventually replied to tell her that she hadn't been accepted this time, but if she'd like to go for another test with him, he'd try to make time to see her and give her another chance. Only at that point did she confide in a friend, who warned her very strongly not to go.

Charlene is sadder and wiser after that experience, and is back at her factory job.

Don't subsidise their hobby: some photographers will even tell you that they are 'artists' and that any mention of money is distasteful – that you can only really be artistic if you work for nothing. What they really mean is that they want you to subsidise their hobby. All hobbies cost money, whether it's watching the local football team, fishing down the canal, or stamp-collecting. If a guy wants photography as a hobby, he has to buy his camera and equipment, hire a studio, learn how to process or finish his photos, and all this costs him money. Why should the model come for free?

Do your own portfolio: so where did the idea of models working for nothing come from? Before the days of digital photography, when it cost a lot of money to develop and print photos, it was common for models to pay a professional photographer to take a series of photos for her so that she could create a portfolio, or 'book', which she then lugged around from agency to agency and job to job, in order to show people what she could do. Things have changed. Although you still need a 'book' (which you can print off yourself from your own computer) if you're being interviewed by one of the top agencies, most models now only have on-line portfolios, which cost nothing at all. The point is that anyone with a digital camera, or even a good phone camera, can take reasonable photos these days, and that includes you and, with a little help from Photoshop, you can create a basic portfolio which is perfectly good enough to get you started. What particularly annoys me is that the vast majority of photographers offering TF shoots have no business doing so because their work just isn't good enough. Would you have your hair done by someone who doesn't know their beehive

from their bouffant? Would you order a gourmet meal from a chef who'd only ever worked in a fish-and-chip shop? Some of these guys have only just bought their first digital camera, yet they think their work is good enough to exchange for your time. It isn't.

Don't be patronised: some photographers boast about having done it for years, but haven't kept up-to-date, and their portfolios contain photos taken twenty or thirty years ago. They will tell you that your portfolio 'shows promise' or that it 'doesn't do you justice' and that they can do a whole lot better. As I said earlier, I'm not saying that you should *never* do a TF shoot – most models do at some stage – but before you commit yourself, or apply for a collaboration casting, look carefully at the profile and portfolio of the photographer. Ignore anything he says about having been a photographer for years – the more they boast, the worse they usually are because their work speaks for itself, and many confuse experience with age. They often don't know the first thing about artistic composition or the technicalities of setting the camera and the lighting, or shooting from the right angles. Many portfolioss are just a collection of the usual rows of over-lit tits and bums, , and lacking originality. *But*, if the photos in a photographer's portfolio make you gasp at how beautiful they are, show a wide variety of techniques and methods, and are clearly out of the ordinary, then fine, you might feel that this particular photographer can add something to your portfolio. Make sure he has lots of good, recent feedback from models who seem to know what they're talking about, i.e. models who also have good portfolios, as opposed to those who will just say 'nice' things to get 'nice' feedback in return.

Do your homework: in other words, do your homework before agreeing to a TF shoot, and make sure what you're being offered is a good deal. For 2–3 hours of your time, you should expect to get at least a dozen completely finished photos, depending on the genre. Some photographers will give you more than that, but they won't necessarily finish the photos so, unless you're pretty good at Photoshop yourself, they won't be a lot of good to you unless they are finished. Make sure it's agreed in writing, not on the phone, and make sure he commits himself to get the photos to you within a reasonable time-frame, e.g. two weeks maximum.

Never pay a photographer: at the other extreme, there are some photographers who expect a model to pay, and won't even offer TF. These guys are the real dinosaurs - you thought they were extinct? – think again! They still cling to the pre-digital days when models paid for portfolios. They don't seem to understand that most models don't just do it for fun (although a few do). We want to be paid for our time, skills, looks, efforts, and our enterprise. We want to be published, and

to get more and more work. Having a nice portfolio is only the beginning, not the end of a model's ambitions. Most good amateur photographers understand this well, but there are few professionals, and many 'pretend' professionals who still think models should work for nothing. I've lost count of the number of times I see the words 'I don't pay models', as though we're a sub-human species. I often have rows with these guys. I ask them whether they also expect other service-providers, like plumbers or window-cleaners to work for nothing. I often have to explain that things have changed: that it's not models who pay photographers, but the other way around, and that if their work isn't good enough to sell, then they shouldn't be using models at all.

Maudie is thirteen and told me she'd dreamt of being a model 'all her life'. Her parents were keen to support her so they paid £600 to a photographer for a 90-minute shoot and a portfolio. She was given ten photos. She quickly realised that it had been a complete waste of money, because she found she was too young to put up profiles on most modelling websites and, being so young, her looks were changing by the day, so the photos would soon be out of date. Moreover, having created her own website using the photos, she then received several TF offers, so then realised that she could have created a portfolio for nothing. The photographer who took £600 from her parents obviously didn't care, so long as he got his money. Many people would take the view that he had a moral obligation to advise Maudie about her limited opportunities while still so young, and that he was exploiting her.

Do as little TF as possible: photographers sometimes complain to me that girls who are in modelling 'just for a laugh' and always offer TF shoots, are notoriously unreliable, and often don't bother to turn up, are late, or are ill-prepared. So photographers who do lots of TF work think we're all like that, and it just doesn't help. So my advice is to do as little TF as possible, and that once you have a dozen or so decent photos in your port, start charging, but make sure you give value for money – I can't stress that too strongly. Respect must be earned, and if we are to be valued and respected by photographers, *we must give value for money.*

If you think I'm exaggerating the attitude that some photographers have towards models on the subject of payment, let me show you an email I recently received. This *female* photographer put up a casting call, saying she was snowbound, so stuck at home, and unable to get to work, but was willing to do a TF shoot at her home for any model able to get to her. I wrote, asking that if she was snowbound, how did she expect the model to get to her, and shouldn't she be offering payment to anyone who was willing to make such a hazardous journey.

This was her reply: 'Excuse me – sorry, but who the fuck do you think you are? Some tart who gets her tits out *(and)* wants money because she knows how

to stand still? – get a fucking reality check love. I do NOT have to pay models – there's 1001 girls who'll get there *(sic)* tits out for nothing.'

It's bad enough to get such crude, illiterate and aggressive misogyny from a man, but to get it from a woman is shocking and disgraceful. It's unbelievable that a woman can have such low regard for other women, and see them as dispensable sex objects whose skills and talents don't deserve payment. I reported this person to the webmaster of the site on which it was sent, but no action was taken.

'Test Shoots': another way some photographers try to get models to shoot for nothing, is to offer 'test' shoots. Unless this is for a bona fide agency acting for a commercial organisation, be very wary. Freelance photographers do *not* need to test you. They can decide whether you are what they want by looking at your portfolio and reading your references. So if you are approached by a photographer acting on his own behalf, who insists on a test, decline the offer. It is just a power game, and a con. It puts the photographer in the position of the headmaster 'interviewing' a new pupil, and the model is expected to cringe and bow, and be a good girl. She thinks that if she passes the 'test' she will be offered work (like Charlene, in the story above), but the reality is that 95% of 'test' shoots are fake. They are just another way for the photographer to get a model for nothing. He shoots her at the 'test' then, no matter how good she was, he tells her that she didn't quite come up to scratch, or that he will 'let her know' or that the contract he was going to shoot for has fallen through, and he's been let down. It's all bullshit. It's the model who is being let down, and not softly, either. The photographer has taken shots for nothing, and he will use them as he sees fit, knowing the model will probably never find out and that, even if she does, she will never complain.

Portfolio 4: Alternative and Retro

Alternative modelling covers many genres in which the models do not conform to ideals of mainstream beauty. These include gothic, urban, latex, fetishism, retro, cosplay (costume play), Lolita, and burlesque styles. If you are heavily tattooed or pierced, this type of modelling could be your specialism and trademark, but you can do other styles as a side-line. Even if you aren't primarily an alt model, it's still a good idea to have alt modelling pictures in your portfolio. Alt modelling covers many genres of modelling from fashion and beauty, to commercial, glamour, art nude, and adult styles. Alt modelling is more acceptable these days, and many girls experiment with their style, hair colours, and even piercings to enhance their look.

© Colin Nash

© Outofrespect

© Outofrespect

© Iridium Photographics

© Outofrespect

© Paul Bartholomew

© Mark Willis

© James Bessant Photography

© NIRD

© Outofrespect

© Outofrespect

8. How to arrange a shoot

Use a diary: a model friend of mine once said 'If a shoot isn't arranged in the space of two or three emails, it ain't gonna happen'. By that, she meant that you get a lot of photographers who dither and pontificate, and just waste your time, but don't actually commit themselves to a date and details. Some want to talk on the phone instead. *Don't*. Be polite, but be firm. Ask them to suggest dates, location, duration, start time, and levels. Discuss or state the price. When they've replied to that, put it in your diary, then ask them what they want in terms of hair/make-up/wardrobe (and print it off so that you've got it to hand to prepare for the shoot).

Texts only, please: ask for a phone number, just in case you need to contact them quickly at the last minute, and give them yours. I don't actually give them my private mobile number, because I don't want nuisance phone calls. I have a separate phone for modelling, and when I give the number, I say 'texts only, please'. That dissuades them from trying to call me. This may sound a bit harsh, but genuine photographers *never* call, and never need to. Like me, they prefer everything in writing so that there are no misunderstandings. So if the guy tells you he needs to 'talk things through', or prefers to 'get to know you' to see if the two of you 'click', and insists on calling, refer him to your references on the modelling site so that he can make a judgement about whether to shoot you or not. If he still insists on wanting to speak on the phone, just move on, and say you aren't interested. He's almost certainly up to no good, or isn't a genuine photographer.

The week before a shoot, I use my modelling phone to send a text to re-confirm. This is important, because it may be months since the shoot was actually arranged, and you can't rely on everyone to be as good at keeping a diary as you are. If they want to back out at that stage, there's still time to arrange something else.

What to pack: when travelling, it's important to think about what you need to pack. Clothing, accessories, cosmetics, and shoes are obvious, but I've heard stories of models turning up to full day shoots with a carrier bag containing only knickers, a bra, a pair of heels and nothing more. Ask the photographer in advance to give you an idea of any styles and colours of clothing he wants you

to bring, and pack according to the length of the shoot. A hold-all or suitcase may be required for a full studio day or tour. Take a variety of outfits and shoes, plus a robe. Deodorant is useful, but also take baby wipes, skin shining moisturiser, pain-killers, and of course an emergency supply should your period come unannounced. And don't forget your business cards! If you are going to be working outside in the wet or in a dirty environment, check with the photographer that he is bringing towels and wipes to clean you afterwards, or bring your own. The last thing you want is to have to climb back into your clothes all wet and dirty, and then travel home again. If you are going to an interview for an agency or casting they may ask you to bring a set of white or black underwear and high heels. Pick a set that look plain but flattering, and wear attractive but appropriate attire.

9. Shooting at home and away

Home: you will get a *lot* more work if you are able to host shoots at your home, because most hobbyist photographers can't host and don't want to pay for the hire of a studio – of course, your home needs to be suitable. The bigger it is the better, but if it's small, then at least make sure it is tidy and clean, and that there are a variety of backgrounds for the photographer to place you against. Once you've done a few shoots you might like to invest in some lighting and, if you have the space, even some backdrops. If you also have a garden with a good degree of privacy, all the better.

Away: you will also need to travel to shoots, and this actually provides nice variety to your work. I have a lovely home studio, but I've shot there many times that I love going to new places and, provided the shoot is long enough to make travelling there worthwhile, I'm always pleased to go.

Chaperones: when you get your first away shoot, you might wonder if the photographer is 'safe' and think about taking a chaperone. There are very mixed views on this. Some photographers don't mind at all, as long as the chaperone keeps out of the way. At the other extreme, some simply won't allow it, especially if the chaperone is your boyfriend. I can understand that if the studio is very small, like a back bedroom, then it's awkward, and I don't blame the photographer for not wanting a stranger wondering around downstairs while you're working with him upstairs, but others refuse it because they say it interferes with their 'intimate' relationship with the model. That's bullshit, of course, because professionals can work in any situation, and never be distracted, whether they are models or photographers.. I've worked with huge crowds watching me naked, or with several photographers at the same time, indoors and out, sometimes in public. Given the fact that a model might make a false allegation against a photographer, it seems foolish and short-sighted for him not to want to have a witness present. However, having said all that, no respectable photographer would ever risk stepping out of line, and in all the hundreds of shoots I've been to, there has never been a problem, so I don't take a chaperone. We all carry mobile phones these days, so help is never far away.

One photographer asked me to go to him for a shoot, but wouldn't give me his address. He claimed that he'd had problems from models' boyfriends in the past (I wonder why?) so I was to meet him in a coffee bar, and then he would take me to his home. How stupid is that? *Never* go to a shoot unless you know the address, and have told someone where you are going!

NIP shoots: you might be asked to do a 'Nude in Public' (NIP) shoot. The law on doing nude shoots in public places in the UK is a bit vague. It's not actually an offence to be nude in public, but you could be arrested for causing alarm and distress, so obviously you don't want to take any risks. As well as having the photographer with you, it is best also to have a look-out so that you can be warned to cover up quickly if anyone comes into view. Avoid very busy places, and definitely avoid places where there are likely to be children. A good time to do it is very early in the morning. Because of the risk-factor, I charge a higher rate for NIP work.

Studio days: another option is to do studio days. This involves making contact with studios around the country and asking if they would like to organise a studio day for you. It usually means you getting up very early to travel to a studio, working eight or nine hours, for a rate slightly below what you would accept at home, because the studio needs to top-load the price to make its own money. But the advantage of a studio day is that when the photographers meet you, they often want to book you again, and will be willing to travel to you in the future for a longer shoot. Some studios will want to offer a repeat booking if it goes well. Unfortunately, some studios try to cream off too much profit, and insist that the model works for a pittance. Others claim their local photographers won't pay above a certain amount, of which the studio takes a share. This is simply to persuade you to accept a very low hourly rate. The fact is that lots of local photographers are happy to pay a high rate for one hour, rather than have to travel a long way to visit a model at her home, and be faced with a minimum shoot length of 2 or 3 hours. I've done a lot of very successful studio days, where photographers happily pay an hourly rate which is 50% higher than my normal rate, and have no problem in filling the days, sometimes two days on the trot. So if a studio asks you to accept a very low rate, go somewhere else. You need to monitor the recruitment to your studio days because, while some studios are brilliant at marketing, others don't have a clue, and need a lot of hand-holding.

Plan for a tour: as mentioned earlier, I now do most of my tours by hiring a cottage or city apartment, and ask the photographers to come to me. It's essential to book a good quality venue: spacious and with nice features. There are lots of websites offerings quality cottages, many in lovely areas of natural

beauty, an there are lots of large, open-plan apartments to be rented in all the main cities. They tend to be expensive, but provided you fill the week, you'll easily cover the rent and travelling expenses, and still make a good profit. You'll need some plain walls for backdrops which don't have too much clutter (put all those china ornaments away in a drawer), good natural light, and quality furnishings. If you have any, it's a good idea to take your own professional lights and accessories with you, because not every photographer has them or wants to transport them. Start planning the tour about two months in advance, and don't book the cottage until you have enough bookings to cover the rent. Make sure to check the Terms & Conditions before you make your booking so that there will be no problems about your having visitors to the cottage to take photographs. If you can, avoid cottages which are adjoining or next to the owner – you need space and privacy, and don't want someone watching all your comings and goings.

I tend to offer morning, afternoon, and evening slots, with good discounts for those taking a full day, and I provide refreshments. Get a full brief from each photographer before you leave so that you have everything you need for the week – probably two or three suitcases full of clothes and props!

Shoots abroad: 'Come and join me and lots of other models on my yacht in the Caribbean for a fortnight's modelling. Everything provided, top rates paid'. Sounds fun, doesn't it, but sorry, it's just one of the many scams you'll get on a regular basis. Going abroad for a shoot is the most dangerous thing a model can do, so she needs to have lots of safeguards in place. If you've worked with the photographer before, then fine, but if you haven't, how do you know he is safe, or that he will pay you? Being abandoned in a foreign country with no money is bad enough, but it's worse if you're trapped in a remote villa with a guy who won't take 'no' for an answer. So, *never* go on a shoot abroad unless the photographer has either bought you the flight tickets in advance (or paid you the money to do so), has booked you good-quality accommodation (which you can check) and has paid you at least half of the agreed fee before you leave the country – or has impeccable references from girls who've gone before, references which you can check.

Money: if you're travelling to meet a guy you haven't met before, you've already spent money in getting there, and you have no guarantee he's going to pay you, so it's best to ask for the money on arrival. This is normal in most business transactions, e.g, when you check into a hotel, you give them your credit card details so they have some security, or if you buy a take-away meal, you pay before you eat it. Most photographers are happy to pay at the beginning of the shoot, and it's certainly best to get that out of the way so that you can then both concentrate on the shoot. If you leave it until the end, you run the risk that

the photographer might say he hasn't brought enough cash, and ask to pay by cheque. He might even query the amount you are expecting to receive, and it's too late to argue once the shoot is over. It's possible to agree to an instant bank transfer, using a laptop, but cash is always the safest and best bet. It's different if you are doing a shoot for a big organisation which insists on paying at a later date, or if you are with someone you have worked with many times before, so you need to use your discretion. Looking at it from the photographer's point of view, some might argue that if they pay you up-front, there's no guarantee that you will give them the shots they want, or that you might be difficult to work with, or leave half way through. Obviously, they will have checked your references and minimised their risk by hiring a recommended model but even then, if you don't perform to their satisfaction they can ask for the money back or, worse still, write you such a bad reference that you will never get work again, so their risk is pretty well covered, whereas yours can only be covered by asking for payment at the beginning of the shoot.

Deposits: some photographers offer to pay deposits and I've often been asked why I don't charge a deposit every time I accept a booking. The problem with this is that I think it would scare some photographers away. If they haven't met you before, and you're asking them to send you a deposit ahead of the shoot, they have no guarantee at all that you even exist, so their risk is even bigger than you not getting paid at the beginning of a shoot. What I do, instead, is to make it clear on my website that shoots cancelled at the last minute need to be paid for, unless I can find a replacement. I've only had a few last minute cancellations, and every time the photographers concerned have been happy to pay up. I then offer them the chance of another shoot in the future at a big discount, which I feel they deserve for their honourable behaviour.

On a recent tour, one photographer had to cancel at the last minute due to family problems, but took the trouble to drive all the way to the cottage where I was working to give me the cash. I was very touched. Another, on the same tour, had an accident early in the day of a full day shoot, and had to be taken to hospital. As soon as he was out of hospital, he sent me a cheque for the full amount, including the expenses I had incurred in taking his stuff to the hospital for him. These are the good guys, and they're worth their weight in gold.

Portfolio 5: Parts

Parts modelling is great if your 'parts' are good enough, e.g your legs, feet, hands, bottom, or even your torso. You can do parts modelling as well as, or independently from, other types of modelling, and if you have good features it's another way to show your diversity. Close-ups and parts modelling is also good to have in your portfolio because it shows off your good skin and features in a way that other photos cannot do.

© Ian Boys

© JK – SW Photography

© Gary Jenkins for Retro and Lace

© PWP Images

© JSFA Photography

© Ian Boys

© Mark Russel

Tights.

© Outofrespect

© Outofrespect

10. How to prepare for a shoot

Diet and exercise: your body is your tool so look after it. This doesn't mean heavy dieting and living in the gym, but it helps if you eat small, regular meals, and try to keep your weight consistent. Eating small meals encourages a higher metabolic rate, and also helps your stomach to stay smaller, meaning it will look flatter in pictures. Doing a little exercise also helps – not the heavy strength stuff, but gentle swimming, cycling, or running to benefit your heart and lungs, and to keep you toned, plus some flexibility exercises. Flexibility is very important for some shoots, where the photographer wants you to adopt and hold poses which are gymnastic or balletic, where you need to be supple. You may also get requests to shoot in or under water, and that certainly requires a degree of fitness, plus the ability to keep the right expression while holding your breath for long periods. If you are fit and healthy, you are also more likely to be able to cope with extremes of weather when shooting outdoors. I've shot naked in the snow and rain on many occasions, as well as in temperatures of over 40 degrees in the tropics.

Skin care: find a good skin care routine that suits you, and try to stick to it. We all get the odd rash or spot outbreak, but you want your skin to be as good as it can be, which then makes it easier for the photographers in post-processing. If you suffer badly from acne or have a poor complexion, you must be honest about this when applying for shoots.

Make-up: invest in good make-up. Pharmacy brands are ok, but the best are brands that specialise in make-up for make-up artists. If you are not particularly confident in applying it, there are places you can take a short make-up class. There are also lots of tips and tutorials on YouTube for you to try, and then find what suits you.

Shoots where there is a make-up artist (MUA) are rare, so freelance models need to develop make-up skills if they are to make the best of themselves and be able to prepare for a wide variety of shoot themes. Most importantly, you need to learn which styles suit you, and so spend time looking at yourself in the mirror, and study your face and feature. Are your eyes round or almond-shaped, big or small? Do you have thin or full lips? Look at the shape

of your brows and your cheekbones. If you have thin lips you can work around this by choosing lighter colours and glosses to create a volumnising effect. You can also draw a fake lip line slightly outside your natural lip line, try to make it look natural and match your lipstick colour. If you have round eyes avoid harsh eyeliner under the eyes which will accentuate the roundness, and adopt a softer, smudged eyeliner under the eyes. Using liquid eyeliner above the eyes, or individual false lashes in the outer corner of the eyes, can elongate them a bit more. If you have small eyes you can make them look larger with cat-eye eyeliner and using neutral eye shadows on the lid, with a darker colour in the crease to open the eye up. Smaller eyes can also wear a heavier eyelash better than larger eyes, because they make larger eyes look too big, whereas they nicely balance smaller eyes out. If you have a round, diamond or square face shape you can reduce your jawline by applying a light contour around the problem areas, and if you have flat cheekbones, you can create a false cheekbone with a drawn contour line.

Eyebrows are really important because they affect your whole face, changing your expression, and can make you look sexy or silly depending on whether you get them right or not. If your eyes are small, you can get away with a thinner brow, to open up your eye socket, but take care not to over-pluck (unless you are playing a 1920s film actress). Your eyebrow positioning also needs to be looked at, so get a ruler or pencil and hold it vertically next to your nose: the bit where it touches your brow bone is where your eyebrow should start. If your brows are too close in the middle, you can look angry all the time (not a good look). Hold the ruler so it lines up the side of your nose and the corner of your eye, where the end touches your brow bone is where your eyebrow should finish. This is so it looks proportional to your face and applies to 99% of people. Using clear mascara and an eyebrow pencil to define those arches is great, get a colour that matches your hair colour. Try to avoid harsh squares to the ends of your eyebrows, try to make them look natural when defining them. Avoid fashion-eyebrows like 'Scouse' brows, which seem to be popular around the Liverpool area at the time this book is being written!

If you are going to wear false eyelashes for shoots buy good quality falsies. Cheap ones with the tough black strip aren't good, nor are the ones which don't look remotely real, or dwarf your eyes (unless it's for a beauty shoot). Get the eyelashes with a clear strip, or individual fan lashes. Remember less is more, and the lashes must match according to how heavy your make-up is. A great tip when using strip lashes it to cut them in half and use half of them on the outer corner of your eye, you get double the use and they look more natural. Having said that, there are ways you can boost your eyelashes with the right mascara, and eyelash curlers, for a more natural effect. Many types of mascara have tiny fibres in, which adhere to the ends of your lashes and make them look longer.

Learn several different looks which suit you including a natural look and a more dramatic and glamorous look. Remember that if you are wearing a light eye make-up you can get away with a heavier lip colour, and vice versa, so choose lip colours carefully. Dark shades can be too much and a paler colour usually looks much better. All this said, choose colours that suit your skin and eye colours. Warm tones look best for skin with yellow undertones, while cooler tones can work with paler and more neutral skin colours.

Nails: if you don't have lots of time to maintain your toenails or fingernails, it's best to opt for a natural look which goes with everything, because bright colours look scruffy when chipped, and may clash with the theme of the shoot.

Teeth: you can't get through many shoots without opening your mouth and showing your smile, so if you have crooked or discoloured teeth, it really is worth getting them done. Discoloured teeth can be bleached or veneered, and braces are cute, so don't be worried about having to wear one while your teeth are being straightened.

Smoking: not only is smoking dangerous to your long-term health, but it is the enemy of modelling: it stains your teeth and fingers, gives your skin a pallid, yellow, and wrinkled appearance and it makes you and your clothes smell stale. When a smoker walks into the room, everyone else can smell her. If you're serious about modelling, give it up! I know several photographers who would never hire a model who smokes.

Drugs and alcohol: I'm beginning to sound like a nagging teacher, but it goes without saying that a model turning up 'high' or drunk to a shoot can expect to be shown the door. Nothing more to say on that, except that a 'professional' wouldn't do it.

Hygiene: it's especially important to be hygienic when modelling. I have heard awful stories about models who smelled, or who left used tampons lying around, or who left stains in garments supplied for the shoot by the photographer. Not nice. If you are doing nude modelling clean yourself and stay clean. If it's time of the month, make sure the little string is tucked away – you don't want that in the picture.

To shave or not to shave: obviously, shaving the pubic area is a matter of personal preference, but don't assume that you *must* shave to get work. The opposite is actually the case. I maintain a neat, natural-looking triangle on top (I tidy up underneath) which gets me a lot of work, especially for art nude, where the natural look is preferred. It's also desirable if you want to do retro work – it

helped get me an acting part as a centrefold model posing for *Men Only* in the mainstream film *The Look of Lov'* where I worked alongside stars like Steve Coogan, Stephen Fry, Anna Friel and David Walliams.

A natural triangle can even help with lingerie and implied nude work, where a 'shadow' under the clothing is desirable. In all the time I've been modelling, I've only been asked on two occasions if I would consider shaving. I said 'no'. Until relatively recently, women didn't shave at all. It all seems to have started in the American porn industry back in the mid-eighties where many of the film-makers wanted the performers to look pre-pubescent ('schoolgirl' porn is one of the biggest markets) and it didn't become popular in the UK until the early nineties. So it has very iffy origins, and I have to say I do wonder about the guys who like their women to look like children down there. But, as I said, it's a personal thing, so if you prefer it that way, then fine, but don't be pressured into shaving for a shoot – it takes a long time to re-grow, and you end up looking like a plucked chicken for weeks, complete with a shaving rash and spots!

Fakery: fakery is expensive and very time consuming, but many models, especially glamour models, have lots of fake additions such as hair extensions, fake tan, eyelash extensions and false nails. Sometimes these work well, but they are very time-consuming to maintain, and can look awful if neglected. I am frequently told by photographers how nice it is to work with a model without a patchy fake tan, because it is impossible to edit out. Hair extensions can be a nightmare too, because the joints often show during movement, and you can't get them wet during shoots, or swish them around without risking pain or damage to your hair. If you want to use hair extensions the best ones are temporary clip-in ones.

Tattoos: tattoos can look great in moderation and when thought through properly, but they can also limit the work you can do because many photographers don't like them. Models without tattoos are more likely to get work over those with tattoos, except for shoots involving 'alternative' work such as extreme fashion or bondage. So, think before you ink!

Skin marks from clothes: when travelling to a shoot it's important not to wear tight clothing which may leave marks on your skin. This includes bras, elasticated pants, jeans etc, and is especially important if there is little time after arriving before the shoot starts. So wear something loose, and if you're shooting from home, wear a robe or dressing gown.

11. How to conduct yourself at a shoot

Before the shoot: at some shoots there will be a make-up artist, but this is the exception rather than the rule, so always allow yourself plenty of time to get ready. I usually allow a full hour or two for hair, make-up and getting the wardrobe items ready before a home shoot. For an away shoot, depending on the distance, you can have most of it done before you leave, and then arrive early enough to touch-up your make-up and dress for the first set, so that you start at the agreed time. So, when you are travelling to the shoot allow extra time. It's better to be half an hour early than five minutes late, so allow for delays. Extra time gives you chance to relax after travelling, and to prepare yourself by laying out your clothing and accessories so they are easy to access. It also gives you time to be introduced to the photographer with no pressure to start working immediately.

Keeping to time: some photographers coming to your home will ask for setting-up time. I'm usually happy for them to arrive 15-20 minutes early for this purpose, but a few take advantage by arriving 30 minutes early, and then take another 30 minutes to pack up at the end, meaning they've had an extra hour of my time for nothing. Strictly speaking, they should pay for my time whether they are shooting or not, but I usually exercise discretion and show good will by not complaining about this. It's certainly not a problem if it's an all-day shoot, but if it's very short shoot, then really, the photographer is taking liberties. I'm sure many of them will complain that models are often late, so they feel justified in pinching extra time when they can, so just make sure you're not one of those models!

Be friendly: when you meet the photographer, make-up artist, or other models, it's really important to greet them with a friendly smile, eye contact, and possibly a handshake. The photographer may be nervous if he is new to it, so you need to make him feel relaxed. Nothing does that better that a smile, a joke and a laugh. A cup of tea or coffee and a five minute chat covering the aim of the shoot also helps a lot. It offers an opportunity for you to make suggestions and show your engagement in the project. If the photographer doesn't automatically offer his ideas about the shoot it's a good idea to ask. I also offer more tea/coffee

throughout the shoot, often with cake or biscuits, and a light working lunch to those doing a full-day shoot.

During the shoot: make sure to put all your effort into your work. It's your job, and you're lucky to be doing something you enjoy, so be grateful and make sure you offer the photographer value for money in the form of effort and involvement. Take direction and make suggestions. Be patient, be polite, and work with the photographer to ensure he gets the images he wants.

Music and chat: it helps to chat or play some music during a shoot, if the photographer is happy with that. If you don't make an effort to chat to the photographer, the silences can become long and awkward, and this might affect the quality of the pictures. Some of my best shoots have been when the photographer and I have a laughed all the way through. Time flies when you are enjoying yourself and feeling comfortable! Don't be afraid to suggest ideas and try different poses. The photographer might not have thought of it, and will be grateful for your input. But don't forget that he's the one who is paying, so don't be bossy about it.

Giving help and advice: as well as being a model, I'm a keen photographer (as you can see on my website: www.lizziebayliss.co.uk); so, sometimes, photographers just starting out, or who are new to working with models, ask me for advice. This can be about setting the camera or the lights, or about how to get the best from a model. I even run tutorial days for photographers wanting this kind of support, but only charge them for my modelling time. If you are asked for this kind of help, make sure to use a lot of tact! These are usually mature guys, after all, and you're a young female, so you don't want to deflate their ego by making them feel rubbish. Temper your advice with humility, and always praise them when they get things right. It will win you friends, and return bookings!

Portfolio 6: Lingerie

Lingerie modelling generally refers to commercial lingerie modelling or boudoir-style images which make the model look beautiful. They are flattering, and usually have a soft and feminine feel about them. Commercial lingerie modelling shows the lingerie off and makes the model look as though she is enjoying herself and feeling sexy, either in an elegant or interesting location, or in a studio.

© Outofrespect

© Stuart McGregor

© Outofrespect

© Iridium Photographics

© Mark Moses Johnson

© Colin Nash

© Outofrespect

© Floragraphy

© PM Photography

12. How to pose

Yn'll have noticed that I have punctuated this book with mini-portfolios to illustrate some of the genres available to freelance models. These portfolios include fashion, beauty, commercial, alternative and retro, parts, lingerie, glamour, art nude, erotic and pin-ups. For each genre, a different set of posing skills is required. Most styles have an emotional theme running through them which helps you to pose accordingly.

Facial expressiveness is very important. A while ago, I was looking at pictures of a gorgeous new model who had completely mastered the 'sultry' look. The trouble is, the photographer told me that 'sultry' was all she could do, and a month later, she had disappeared from the website in question. One expression just isn't enough, so practise different expressions until you have a wide repertoire to fit every kind of shoot you're likely to do. For example, learn to widen or narrow your eyes – do it in the mirror, and see how it changes everything.

Here are some examples of moods within modelling styles to help you set the right expression.

Glamour: glamour is happy, fun, playful, confident, sultry, cheeky and seductive. It involves lots of eye contact with the camera, raunchy poses, smiling and pouting. The pictures produced are the kind where the eyes follow the viewer around the room from every angle. The don't say, 'look at me', but 'I'm looking at you', so remember when you are posing to look 'through' the camera at the eventual audience, rather than think about the camera looking at you. In other words, project yourself, and communicate the mood.

Art Nude: art nude is normally based on more serious emotions such as sadness, sorrow, thoughtfulness, shyness, calmness, and serenity. Most art nude involves minimal eye contact with the camera, with the model looking down, away or to the side. Poses are often soft, modest, and romantic, or in contrast can be bold, acrobatic, and unusual. Cameras and lights are often set to produce muted colours, or black and white to enhance the mood.

Commercial: commercial modelling is usually based on warm emotions to convey a happy and perfect life. These include happiness, confidence, joy and tranquillity. Poses are not 'sexy' and are very neutral and relaxed most of the

time, with the model looking at the camera or behind the camera, or interacting with other models. You are the girl next door, or the girl on the office – natural, bright, healthy-looking and vibrant.

Lingerie: here you need to be calm, relaxed, and thoughtful. Most lingerie modelling is about flattering the model and the lingerie and making both look appealing without being overtly sexy like in glamour shoots. Poses will normally be natural, comfortable, and feminine, and the model will usually look at the camera, or just behind the camera.

Pin-Up: traditional pin-up modelling involves retro clothing and femininity, with lots of warm emotions such as happiness, shyness, playfulness and surprise. Poses will often be ridged, with hands and legs playing a large part. Hands must look delicate and dainty because they often complete a pose, especially when using props or holding clothes. Legs will often be a main focus, so they must always be in a pose that makes them look long and shapely. Facial expressions are usually big smiles, demure pouts, or playful shock (e.g. as her skirt blows up to reveal her underwear and stockings). The essence of this type of posing is comedy, with the audience laughing at the naivety of the model's pose or expression, so the model must have good acting skills, and not appear to be in on the joke herself. We laugh at her, not with her.

Adult: this genre is generally about sensuality, confidence, femininity and sexual arousal. Models have to look happy in their own body, relaxed and must appear to be enjoying themselves. Poses are normally looking at the camera or in the direction of the camera, but also down at their own pants/stockings etc, and eyes are normally closed during the 'deed' to show natural enjoyment. Storylines tend to be similar (and a bit boring!) so the challenge for the model is to make it look original. Good acting is essential. Some photographers at the sleazy end of the market might ask you to have an 'orgasm' and some even claim they can tell when it is faked. Yeah, yeah. They live in a porno fantasy world and think that because they're getting off on it you are too. Just be professional, and laugh all the way to the bank!

Fashion: the idea here is to show confidence and dominance, so that the model looks happy and in control in the clothes she is wearing. Lots of fashion modelling involves quite masculine or unusual poses, with sharp angles to the limbs and rigid postures. Facial expressions tend to be neutral or fierce, with the model looking down, away from camera or staring blankly into the lens. Some fashion modelling has a more relaxed and natural approach, where models smile and interact in a seemingly cool and confident way, looking into the camera more often, and perhaps smiling. It all depends on what kind of fashion you are modelling, so discuss the theme with the photographer before you start to make sure you choose the right emotions.

Video: video work is much more demanding for the model because, instead holding a pose for seconds between shots, she needs to stay in role for up to

fifteen minutes without a break. For that reason, I always charge a premium for video work on top of my stills rate, except on those occasions when I have agreed a set rate for a full day of stills with video. Video can be used with all genres, but it's more common with adult work. Sometimes you are asked to look directly into the camera, while other times you must pretend that the camera isn't there, and avoid eye-contact with it at all costs, just as actors do in plays and films. Mostly, video is unscripted, but you might be asked to say a few words into the camera, especially at the beginning, perhaps to introduce yourself, or the scene. Get a full brief about what is required and make sure you are happy about everything before agreeing to it. Turn off the phone, and the chiming clock, and ask the workman next door to stop hammering for ten minutes, because you don't want unplanned sound effects. Remember, video can't be Photoshopped, so the set needs to be perfectly tidy - look to see what is behind you, and make sure there's nothing to distract the viewer, like open doors or drawers, or shoes and clothes left lying on the floor. The photographer should really be checking these things, but don't depend on it!

Think ahead: posing is like acting, but with a series of freeze-frames in the middle. If you imagine yourself in the mood of the shoot, and act out the movements that fit with this, then it makes it really easy. If the shoot is meant to create some sexy images, do poses that make you feel sexy. When the shutter clicks, start thinking of another pose to move into, or a way to change your current pose. To practise, collect pictures from magazines, or search the Internet for ideas.

Posture: try to be aware of which parts of your body are sticking out, and which parts are sticking in. In my very first shoot I was told 'shoulders back, tits out, tummy in!', and I've never forgotten that. But it's also about extending your legs and arms, and thinking about what your fingers are doing. Too often models forget about their hands, and their fingers look like a bunch of bananas on the end of a stalk. The same applies to feet. Ballet dancers have to learn this in their training. They are told that the pose they are holding must run right through to the tips of their fingers and toes. Think also about how you are holding your head, and don't forget it moves up and down, and also from side to side, and every position is a new pose. I naturally stand on tiptoe a lot and, without thinking, this adds three or four inches to my height, as well as improving the shape of my calves by tightening the muscles.

Angles: when you have been modelling for a while and have seen yourself in photographs from different angles, you get a good idea of which camera angles work on the human body, and which work best for your body in particular. You can use this knowledge to alter your pose depending on the angle of

the camera, tilting your body away or towards the camera to help correct any disproportionate angles. One classic mistake is when photographers try to take a full length shot from standing, because looking down on a model makes her body appear long, and her legs short, which is the opposite of what you want. This angle is very unflattering and almost emasculating, because men have longer bodies and shorter legs compared to women, who have naturally have shorter bodies and longer legs. A lady of 5'4" may have the same leg length as a man of 5'11", but his body is longer to make up the height.

Try and be as versatile as possible and take on different roles and styles. If you haven't done something before, then there's a first time for everything, and another chance to expand your repertoire.

13. Working with other models

There will come a time where you will get the opportunity to work with other models, either as part of a group shoot, or a shoot where the photographer has booked you both exclusively to work together. Avoid the male models who approach you directly, asking to work with you. They are either after sex, or they want to cash in on your success. The request should come from a photographer or an agency.

It's important to relax around other models, and not to feel intimidated, even if they are more experienced than you. I find that an open and friendly approach always breaks the ice, and I've always ended up becoming great friends with the models I have worked with. We keep in touch, giving one another advice, and sharing information about photographers and shooting opportunities.

Do you suit one another? When photographers are choosing models to work together it's sometimes hard for them to visualise what they will look like posing together, so it's often up to the model to make suggestions and give advice. Some models just don't go well together. I was recently on a group shoot where a busty model of 5ft10 was asked to work with a toned, slim-line model four inches shorter, and although both models were beautiful, their heights and shapes were not a match, so the pictures didn't work out, and I think they both felt awkward about it despite getting on well with each other.

Check what the photographer wants: you may be asked to work to boy/girl or girl/girl levels, this can range from anything such as fashion/lifestyle, to artistic nude, dance, erotica, soft or hard adult levels, so you need to check what the photographer wants from the shoot, to make sure you are comfortable with it. Artistic and commercial styles of modelling with other models is fine, but where any degree of nudity is involved, just check beforehand what is actually required, and don't feel pressured by the fact that the other model may be happier doing higher levels than you. In most art nude and lingerie shoots involving g/g and b/g, the picture produced makes the models look attractive and sexy, but not overtly erotic. Any touching is purely incidental, and certainly not sexual.

Hard and soft: hard and soft adult levels are difficult to define because they can mean different things to different people. Soft levels can include anything from simulated kissing and romantic or sensual poses to actual kissing and simulated sex. Hard levels can include sexual fetish, BDSM, sexual touching and a variety of sexual acts. This is why it is important to ask what the photographer wants to avoid any awkward moments on the day. If you are thinking of doing hard levels, I would suggest going through an agency which specialises in this, where you will be provided with legitimate and safe work with performers who are regularly tested for their sexual health, and with companies who will pay properly and act in a professional way. On no account should you risk doing hard levels with a lone operator. Watch out, especially, for photographers asking for POV or Gonzo – it usually means that they are just guys who want to film themselves having sex with you. They may claim to be 'professional' and make a variety of boasts about who they know and what they've done, but the reality is that these guys are just pretending to be photographers/videographers when they are really just sex pests.

Portfolio 7: Glamour

Glamour modelling involves subjects being portrayed in an attractive or sexually alluring way. It may be fully clothed, lingerie, topless or even implied nude, but it is less explicit than Playboy nude or adult images, leaving more to the imagination. It has been around since the days of French postcards sold by street vendors, and became more popular in the 1950s when Marilyn Monroe and Bettie Page modelled for Playboy magazine. Traditional glamour modelling involves classy outfits, elegant and fun themes, whereas modern glamour portrays a more youthful and carefree style of modelling with a deliberate 'amateur' style of lighting to make the models seem less 'unreachable', and more like the girl next door.

© Outofrespect

© Catchlites Glamour

© Chris Zietek

© Ed Melville

© Outofrespect

© Mark Willis

© Outofrespect

© Outofrespect

14. After the shoot

Model release: once the shoot is over, you may be asked to sign a 'model release' form. By signing it, you give your consent for the photographs to be published or used on a website. If it is a paid shoot, then it's perfectly reasonable for you to be asked to sign a model release because the photographer has paid you for the shots he has taken, so they belong to him. Your fee should include the signing of the model release, and not be something for which you charge extra.

Feedback: as soon as the shoot is over, give the photographer some feedback on the modelling site where you met, and he should do the same for you. Try to be constructive in what you say, and not too gushing. Pick up on his strengths. If it was a paid shoot, and you've signed a model release, he is under no obligation to even show you the photos, let alone give you any copies, but in my experience, most photographers are more than happy to do this, especially if you then display his work on your portfolio, duly credited. Some beginners may not know how to finish photos, so if you've learned how to use Photoshop, ask him if you can have a go on a few – he will rarely object, provided you ask first.

15. Types of photographers

Photography used to be a minority interest, and each town had its high street photographic shop which did weddings. Film was expensive, and had to be taken to the local pharmacy to be developed. But with the advent of digital photography and the Internet, now everyone and anyone can take and quickly distribute photos. We all carry a camera and video recorder, in the form of a mobile phone. This has spawned a huge glut of guys who want to be photographers. Many are genuinely interested in photography, but a good number are rogues, or have deluded opinions about their ability.

'Professional' doesn't mean 'better': it's important to realise the difference between a 'professional' and an 'amateur' photographer 'Professional' simply means that he gets paid for what he does – not by the model, but by the people who buy his work. It follows, therefore, that a professional isn't necessarily a better photographer than an amateur. Lots of professionals in the glamour business regularly sell to a handful of outlets and work to a set formula: they know in advance exactly the kind of photographs that will be bought, and these rarely have much artistic merit; they are just the usual top-shelf stuff, all tits and smiles and bright colours. A good amateur can be a *much* better photographer, because he is far more concerned with the artistic and technical qualities of his photos, and he is also likely to be experimental. I've worked with some brilliant amateurs who shot in black and white or sepia, or who used film instead of digital cameras, and processed their own prints. Some have used antique cameras, where to get just one shot depended on me keeping still for minutes at a time. At the other extremes, I've worked with amateurs who were complete beginners, but keen to learn, and who, despite their lack of experience, behaved in a 'professional' manner, A model can't ask for more than that. Don't assume that professional photographers will be the most business-like. I've worked with photographers who shoot for model agencies, or who are staff photographers for some of the top international magazines/websites, and more often than not they've cancelled at the last minute, changed the venue of the shoot when I was already en route, and generally messed me about. So, 'professional' doesn't necessary mean 'good' or 'best'.

The Good, the Bad, the Indescribable: let me start this section by saying that 99% of the photographers I've met were really lovely guys (I've only worked with a handful of female photographers). You hear a lot of moans about photographers by models, and about models by photographers, and anyone would think it was a battleground, but I guess it's like every other job: people like to moan, and there are bad eggs in every basket. A schoolteacher-friend of mine told me that he spends 90% of his time dealing with a tiny number of disaffected kids who'd rather not be at school, and only 10% on the majority of kids who actually want to learn. In the same way, I think I spend 90% of my time on emails from fake photographers, scammers, misogynists, and guys who think that just because a girl is willing to pose for photos, she's also willing to provide sexual services to anyone who asks. In other words, there are guys who think that modelling equals prostitution, and that models are naive, gullible, and don't need to be paid.

The Good: first, the good guys. I've already given examples of how some guys fall over themselves to be nice to you, so I'd like to pay tribute to the good guys before I go on to talk about the rogues. As far as a model is concerned, a good guy isn't necessarily a great photographer. It's nice if he is, because it's always a pleasure to work with a true artist and someone who is knowledgeable about the technicalities of photography, but it's also a very pleasant experience to work with a complete beginner who is a gentleman. So, the good guy is someone who sends clear, unambiguous, polite emails, which say exactly what he'd like to book you for, and suggests dates when he is available. He may even start by saying how much he likes your work, which is always nice to hear. He will agree the details of the shoot in the space of three of four emails, rarely more, providing you with his mobile number, and anything else you need to know. In plenty of time, he will send you a brief, sometimes with a storyboard to help you prepare your hair/make-up/wardrobe, and may even talk about the details of what he'd like to achieve. He will arrive on time and be fully prepared. He will pay you at the beginning (or at the end if you have worked with him before). He may be a little nervous if inexperienced, or anxious, or he may be mature, calm and reassuring. He will either direct the whole shoot with clarity and precision, or ask for your input as you go along. He will chat and joke with you, and be appreciative of your efforts. He won't perv on you, or try to get into your space, or touch you inappropriately. He won't make crude jokes about your body, or come on to you in any way. He will be totally professional throughout. He may ask you to provide two pieces of ID and might photograph you holding the ID. He might also ask you to sign a model release form. After the shoot he will thank you by word or by text, and say he'd like to do it again. Within the next day or so he will write you a nice reference, and may offer to send you photos, saying he is happy for you to include some in your port (this probably won't happen if he is a professional who sells his work).

The Bad: now let's move on to photographers whose approaches are less organised, and whose motives are often suspect. Some guys ask you to talk on the phone. Not only is this very time-consuming, but it can lead to misunderstandings, so when asked to do that, just make it clear that you'd prefer to arrange everything by email. Don't be drawn into phone conversations unless it's a trusted person, especially when the guy tells you he likes to chat things through before agreeing to a shoot. Many just get off on it, and it isn't necessary. The other trouble with phone conversations is that nothing is recorded. Just after I'd started modelling, I foolishly arranged a shoot with a guy who insisted on doing everything on the phone. I travelled over a hundred miles, and when I got there, he cancelled because he claimed I hadn't brought the clothing he'd asked for on the phone. He was lying, of course – I brought everything he mentioned - but I think he'd just woken up, had forgotten that I was coming and changed his mind about shooting me. I had just wasted my entire day and spent a lot of money getting to him. It was a hard lesson to learn. A real photographer knows what he wants, and will respond with full details quickly and efficiently – and in writing. That's the business way to do it.

Unfortunately, you will also come across some photographers who seem to hate women in general, and models in particular, judging by the way they behave. I've lost count of the number of photographers who have told me they are 'the best in the country' (their ports suggested otherwise) or who said they would be doing me a big favour if they shot me (but wouldn't pay me, of course).

The Indescribable: in most cases you can spot a rogue by the way he writes to you, but occasionally you don't find out until the shoot is underway. On one occasion, I was well into the shoot when I noticed the guy had taken his shirt off. I ignored it and carried on, but a little later, he'd got his socks and shoes off too. I continued to ignore it, but then he stopped and asked if he could take off the rest of his clothes, explaining that he was a nudist, and that he always felt most comfortable when totally naked. I was young and inexperienced, so didn't have the courage to say 'no!' and, in any case, there was someone else in the house, so I let him get on with it. He spent the next hour fully naked. To his credit, I think he was a genuine nudist, and he certainly didn't try anything on, but I do think it was inappropriate behaviour and I definitely wouldn't allow it now. I've since spoken to other models he has worked with, and it happened to them too. So dispensing with surprises like that one, which you may encounter once a shoot is underway, let me give you some examples of the types of rogues who will write to you, and the sort of approaches they make:

The Smarmy Git: 'Hiya Hun, love your work! We were meant to work together! Take a look at my port, then let's do some TF'. *Meaning*: I have no

money but I want a model, any model - so you will do - to shoot with me for nothing. You may or may not get some crap photos in exchange for your time.

The Cheapskate Beginner: 'I'm just getting my portfolio together, so I'm only offering TFCD at the present-time. We could learn a lot from one another…'. *Meaning*: I have no money at all, so I cannot afford to pay you. My work is rubbish, and no one will ever buy it, but I'll give you some of my grotty photos in exchange for your time. I will learn a lot from you (for free), but you will learn nothing from me, except that I'm gormless.

The Lost-for-Words: 'What are your rates?' *Meaning*: I don't waste words on models, like 'Hi' or 'please' or 'how are you today?' or 'love your port', and certainly not words of more than one syllable. Just answer, bitch, we'll shoot, and that's it: wham, bang, and don't expect a thank-you, ma'am. (Ignorant git!).

The Sex Pest: 'Do you do b/g? Fancy a POV shoot which won't be published? I pay well.' *Meaning*: I want to film myself having sex with you and it will be all over in Internet within hours. I don't pay very well, but don't worry, you'll enjoy it. Everyone tells me I look young for thirty-nine. I'm actually twenty-four.

The Film Producer: 'I'm a casting agent for a big film studio (*sends link to the MGM promo website*). Take a look at the attached script, then come for an audition at my London office. You stand a really good chance of getting the lead, which pays $75,000.' *Meaning*: I just stole this old film script from the Internet and I want to pressure you into having sex with me at my Council flat in Neasden. MGM has never heard of me, there is no film or film part. You will get nothing from this except gonorrhoea.

The Agent: 'Hi babe, love your port and you could make the big time, but you need representation, and I'm the man to do it. I can get you loadsa work with big multi-nationals. Come for an interview at my studio.' *Meaning*: I'm a pimp who wants to cream 30% off your modelling fees by doing what you already do (and better than I could do it), so come to my converted garage, where you will do a free shoot for me, and I might also have sex with you depending on how desperate and stupid you are.

The Con Man: 'Come to my luxury villa in Portugal. I will pay your airfare, give you food and accommodation, then a commission of £50 of each set I sell.' *Meaning*: I want to shoot you for free, and I will string you along for months and months, hoping you will give up on ever getting a penny out of me. (This actually happened to me: I went to Portugal three times to see this

photographer and, after waiting eighteen months for my money, I launched a claim against him in the European Small Claims Court. The creep then offered to settle out of court rather than have a judgement recorded against him, and I eventually got most, but not all of my money.)

The Arrogant Bastard: 'You show promise, but your port doesn't do you justice. Call me when you're next in London. I occasionally offer tests, and I might be able to fit you in.' *Meaning*: I want to shoot you for nothing. I can't be bothered to come to the provinces, and I certainly don't pay models. I actually think women are a sub-species, and models are the dregs of society. There will be no offer of work. Consider it a privilege that I'm even willing to give you the time of day.

The Amateur Pornographer: 'We make videos for HotChicksWhoCan'tSayNo.com and NymphoSchoolgirls.com. We pay £20 travel and £25 an hour, 2 hours max. Work to your own levels, no probs.' *Meaning*: I want you to do adult for next to no pay, and will also try it on with you when I'm there. I don't sell to a website, I just want it for my own use, but don't want to pay the proper rate for it.

The Narcissist: 'I am doing a project on sex as an art form, and have chosen you to take part. I hope you like my photo – I'm sure we would create something magical together.' *Meaning*: I am an underage schoolboy who masturbates for nineteen hours a day, and I want to have sex with you in as many different ways as possible, provided I don't ejaculate prematurely. I know you don't do B/G but will try my best to persuade you that you should – with me! (Beware of any guy who has his own photo on his profile!)

The Exploiter: 'I have a planned editorial bridal shoot which will be a collaboration of professionals including a bespoke wedding dress designer, MUA, a cake company, florists, and an exclusive venue. You will get some super photos as a reward.' *Meaning*: Everyone except you is being paid or deriving commercial benefit from this, and you are expected to work for nothing. You will get a few static bridal pics which make you look like Tinkerbell, and it won't help your modelling career in the slightest.

The Picture Collector: 'We are developing a brand new hi-tech website to showcase models. Send us twenty of your best photos, and you will be included in it.' *Meaning*: There is no website, or if there is, no one but me ever looks at it. I'm a 39 year old sad loser who still lives with his mother, and I collect sexy pictures, dirty knickers, and used tampons (this isn't made up, I promise – I've been actually approached by a guy who does it!).

The Dinosaur: 'I find your profile totally confusing. In my book, it's one price for everything. I've been in photography since before your mother was born, and once shot Samantha Fox and Linda Lusardi. Call me if you want to shoot with me. I do everything on the phone.' *Meaning*: I confuse experience with age and can't manage a computer. I haven't learned anything about photography since 1975, and I pinched those page three photos of Fox and Lusardi from the Internet. I think 'Photoshop' is a place where you buy 35mm film, and even taking passport photos is now beyond me.

The Voyeur: 'Hi Gorgeous, do you do g/g stills? I pay top rates and want to create something classy. I have a gorgeous, slim young girl keen to work with you.' *Meaning*: I want to pay you £15 an hour to film you having sex with my size-sixteen wife, and the local geriatric swingers' club will watch the video at their Christmas Stocking-Filler Party.

Lord Pervert: 'I shoot art, not porn. I want to shoot you looking deeply into my eyes while you touch yourself and I want to catch the chemical changes in your body when you orgasm.' *Meaning*: I'm shooting masturbation material like all the others, but I consider myself high-class, so don't admit it. I will get so close with my camera that my glasses will steam up.

The Great Pretender: 'Hiya, love your work, I'm mainly only doing paid work, but if you want to shoot TFP let me know.' *Meaning*: I can't afford to pay a model (or won't), and I pretend that I get paid for my work, but if you look at my rather boring portfolio you will realise that no one has ever commissioned me.

The Photographer's Wife: this is quite rare, but it has happened to me a few times. Some photographers keep their hobby a secret from their wives, and you might get an email or phone call from a wife who is checking up. Some wives might imagine that more is going on than photography when their husband spends an afternoon with a semi-naked young female, and jealousy starts to raise its ugly head. I had one wife who said she wanted to surprise her husband by turning up at a shoot he had booked, so would I give her the address, and the date and time of the shoot. I think the surprise she had in mind wasn't intended to be a nice one. It turned out that, although he had contacted me, he hadn't actually fixed a date, so I was able to tell her that. I never heard from either of them again. I dread to think what might have happened if she had done as she intended.

Portfolio 8: Artistic Nude

Artistic nude photography is different to glamour photography in that the focus is on creativity and the aesthetic, rather than erotism. Nude paintings have been around for millennia, and now art nude photography is one of the most popular genres in the freelance industry, because it celebrates the natural female form in a non- overtly sexual way. Art nude can be undertaken by models of all shapes, colours and looks, and does not involve open leg nudity, or nudity where the genitalia are on show.

© James Bessant Photography

© Outofrespect

© Outofrespect

© JRD Photography

© KB Photographic

© Mike Macefield

© Mel Pettit

© David Waldron

© Oliver Fox

© Knottinfocus

© Eric Crimmins

© Barry Mappley a.k.a.Glamourshotz

© Robin Short

16. Agencies

I often see quite inexperienced, and not very good, models claiming that they are represented by an 'agency'. *They aren't.* An 'agency' is *not* a guy operating from the back bedroom of a terraced house in an inner city in the Midlands! An agency is a properly-constituted and registered business with a staffed office, almost always in London, which genuinely finds work for models. The back-bedroom boys are little better than pimps. They won't find you much work, and what they do find it , it will be poorly paid, especially after they've taken their commission from the fee. Even some of the supposedly respectable agencies aren't all they are cracked out to be.

From time to time you might come across agencies which appear, to all intents and purpose, to be genuine and the advantage of getting onto the books of a big agency is that you will get assignments with marketing campaigns run by international brands. Recently, I applied to an agency which appeared to be genuine. It had a very impressive website, said it had offices in cities through the UK, and some in Europe too, and an impressive client list, so I applied. I was invited to an interview in London. Normally, these interviews are held in quite impressive premises, and involve being seen by several members of staff, and having photos taken as part of the interview process. So I was surprised to find myself being interviewed by one very young guy in a big, busy, all-male office. I could tell by his line of questioning that he knew absolutely nothing about modelling, and when it became obvious to him that I was an experienced professional, he told me there and then that I wasn't what they were looking for.

It all seemed very fishy, so I started digging around and discovered that the whole thing was a scam. They didn't have offices all over the UK, and the office where they interviewed me was just a hired desk in a space used by several other companies. The girls' profiles on their website had been stolen from other sites, and the client list was a work of fiction. They never offered any models work, and what they were up to was persuading newbies that if they went on a modelling course and got a professional portfolio done, they would guarantee them work. And guess who ran the modelling courses and did the portfolios? They did, or at least, the dad of the guy who interviewed me did. 'Dad' was a tenth-rate provincial photographer from Bournemouth, who was ripping off young girls by selling them 'modelling courses' (whatever that is) and portfolio

construction at an inflated price, with a promise of work that would never come. So I reported this guy to Trading Standards.

Even genuine agencies don't necessarily find you much work, or the right kind of work. I was once booked by an agency to go to a photographer who runs a magazine and website. He'd been a client of the agency for many years. Just before I was due to go, I found out by accident that he had convictions for sex offences against models, including one against an under-age girl, and had gone to prison. When I told the agency, they pleaded ignorance, even though they claimed to have sent this guy models at the very time when he was in prison. Needless to say, I didn't go. I've since discovered that the agency stills sends models to this guy, and that he continues to misbehave. The lesson here is that you can't expect agencies to look after you by checking up on their clients.

'Modelling platforms' is a new breed of agencies. They target young wannabe models who are flattered into believing they have great potential and will get lots of work. However, in order to get gigs, the modelling platform insists on doing a 'professional' portfolio for the girl – at a cost of £1400! Needless to say, no work ever materialises. It is just a scam, so don't be flattered by people telling you that you have 'just the right look' and will get 'loadsa work' – they want your money, and will give you *nothing* in exchange, other than a portfolio you do not need. Real modelling agencies only need a few shots taken on a normal camera (usually face, and body in lingerie), to make a decision. They don't need a highly-sophisticated and over-finished portfolio.

If you want to find *genuine* agencies go to http://www.associationofmodelagents.org/. This site contains a directory of real agencies, which will give you unbiased advice. But competition is fierce, so don't be disheartened if you are rejected when you apply to the listed agencies. I have applied to them all, and most have interviewed me, whereas others just rejected me out of hand, despite the fact that I'm a very successful freelance model. I'm now on the books of one of the leading agencies, but it took a lot of applications before I was finally successful, and I still do freelance work.

I've spoken to many really good models who've been to these interviews, and all of them tell the same story: that they are told on the day that they have 'just the right look' etc., but then get a letter a week later saying they haven't been selected. It's soul-destroying – and very expensive, because it involves going to London, paying for the travel, and missing a day's work at your day job. It's good to be selected, and maybe something all models aim for; my advice, however, is to not give up the day job, because only the top agency models make a living from it, and then only for a year or so, until another model becomes the 'flavour of the month'. In others words, provided you work hard as a freelance model, you will probably do just as well as some of the best agency models.

17. Marketing

Building your own website: I've already discussed the use of modelling websites, and ways in which you can draw people's attention to you on those sites, but there are also other things you can do to market yourself as a model.

One of these is to construct your own website. It looks professional, so people will take you more seriously, and you aren't restricted or limited by what you can put on it, as you are on the modelling sites. From time to time, you will get offers from people to build you a website. It's best to ignore these, because either they will cost you a fortune, or they are scams. If you go to Wix.com or other similar sites, you can construct your own site quite easily, and if you use their domain name you can have one for free. Once you have it running, make sure to keep it updated with your latest photos and references, and when you sign your name at the end of messages on the modelling sites, always add your website address. Your website needs to contain basic information like your stats and the sort of work you do, an updated portfolio, and recent references. It's also a good idea to spell out your terms and conditions. Bear in mind that different kinds of people will look at your website – not just photographers - so it's not a good idea to put your email address on your contact page, otherwise you will end up getting spam, scams, and nuisance emails from rogues and cranks. Use a contact form instead, then you can choose to ignore it if it isn't relevant to modelling. In any case, it's a good idea to spell out the sort of messages that are welcome, and those that are inappropriate. You can see my website here: www.lizzielatrisch.co.uk

Blog: I also maintain a regular blog, in which I talk about recent shoots, and post photos. It's easy to run, and costs me nothing, but gets me a lot of business. You can see my blog here: http://lizziecation.blogspot.co.uk/

Social Networking: social networking on the Internet is another way of advertising. I have a busy profile on Facebook, and also a fan page. There's never a shortage of guys on there who are willing to promote me in one way or another. Just one word of caution though: don't be tempted to arrange shoots on social networking sites, or anywhere other than by email, or you will soon lose track of things. You will often need to go back to look up details of what

has been arranged, and it's hard enough finding everything on the modelling sites or in your email box without the added problem of searching chat threads on Facebook!

I also use Twitter, and can share my work there. Twitter allows you to share more explicit photographs than Facebook, such as glamour and topless/nude pictures. People can retweet these pictures and therefore your work gets more attention. Like Facebook, Twitter is useful in that it connects me to lots of potential work.

Calendars: having your pictures on someone's bedroom wall, or in the local garage, as a calendar is always going to be good advertising. You won't find it difficult to persuade a photographer to take a series of images for you in exchange for your time which you can then use for a calendar. It's worthwhile having the calendar professionally made, and you may not make a big profit from it, especially if you don't sell all copies, but you're unlikely to make a loss either. Advertise it at a price which covers the production costs and includes post and packing, plus a small profit for you. Don't forget that posting abroad can be three times as expensive as UK posting charges.

Business cards: it's always a good idea to carry business cards wherever you go, particularly on studio days where you are working with photographers who haven't made direct contact with you (they've done it via the studio), so won't necessarily know how to get in touch with you. Having your business card in their possession can result in a call or email at a later date.

Portfolio 9: Erotic

From the earliest days of photography, erotic nude work was a popular, if clandestine, subject among photographers, but has only been recognised as separate from of pornography in more recent years. Pornography uses strong, bright lights, with no artistic subtlety, and everything in plain view, the emphasis being on the breasts and genitalia, whereas erotic photography is more like art nude photography, in that although the emphasis is sexual, it has an artistic style and theme. Erotic photography may also have fetish themes with more genitalia on show than in art nude photography.

© Mark Russell

© Gareth Reed

© Alex Froom @Teaboy Ltd

© Knottinfocus

© John Duder

The Bottom and the Bath

© Eroticiques

photographer
eroticiques

18. Conclusion

Whether you are a model or photographer, I hope you have found this book entertaining and informative. I hope you haven't been put off by my warnings about avoiding 'free' shoots, or my description of the rogues who might contact you.

Although I spend a disproportionate amount of time dealing with these matters, the fact is that the vast majority of people in photography and modelling are charming, dedicated, talented, hard-working, and fun to be with.

I love the whole scene, and hope that you do too.

19. Lizzie's tips

1. Don't be shy about nudity. Nude models get more work.
2. Learn the terms used for different types of modelling, and be quite clear about what is being booked before you agree to the shoot.
3. Beware of 'level pushers'.
4. Do your own thing and don't be held back by a jealous boyfriend. Try to get your parents on side.
5. Construct a good profile – make it truthful – and put it on all the main sites. Upgrade to 'paid' membership on at least one site.
6. Use all the functions the sites have to offer.
7. Check your mail as often as possible, and answer messages promptly and efficiently.
8. Don't do TF shoots unless the photographer has something worthwhile to offer. Beware of guys who pretend they can pull strings for you in order to get you to shoot for nothing .
9. Never do commercial shoots for free, and never do test shoots, unless for a bona fide agency.
10. Never pay to have a portfolio made.
11. Use a diary, and get everything in writing when arranging a shoot.
12. For away shoots, make sure you take everything you need – ask the photographer for a brief, which should include details of hair/make-up/wardrobe requirements.
13. Do tours and studio days – they get you out, and generate more business.
14. Always tell someone where you are going, and always carry a phone.
15. Never go on shoots abroad with unknown photographers unless you have obtained references and/or have everything booked and paid for in advance.
16. Unless you know the photographer, or he represents a big company (which you can check) it's best to ask for payment in cash at the beginning of a shoot.
17. Stay fit and healthy – look after your body - and avoid cigarettes and drugs.
18. Never wear tight clothing immediately before a shoot.
19. Allow at least an hour before a shoot to get ready.
20. Always be 'professional' and friendly.

21. Practise posing.
22. Give the photographer constructive feedback.
23. Avoid the 'bad and indescribable' photographers. If it feels wrong, it probably is.
24. Beware of fake agencies which promise you work in exchange for you paying for portfolios or training. *Never* pay to join an agency.
25. Don't give up if agencies reject you – keep applying.
26. Market yourself – construct a website and get busy on social networking.

Portfolio 10: Pin-Ups

Pin-up or 'cheesecake' photography dates back the 1890s when burlesque dancers and actresses had business cards to make them more noticeable to the public and potential employers. When movies arrived, fans would cut out pictures of their heroines from newspapers and pin them to the wall, hence the term 'Pin-up'. Traditional 'Pin-up' pictures involve a pretty female model showing her underwear or stockings, and reacting in a fun and shocked manner. The idea that she is shocked or hasn't noticed yet, suggests that she is virtuous, and not a promiscuous girl, hence the viewer is given a special treat, whereas modern pin-ups can involve nudity and less subtlety, and a wider range of expressions. The retro style pin-up is currently the most popular, with photographers and models looking to Gil Elvgren for inspiration, using 1940's or 1950's styling.

© Mel Pettit

© Outofrespect

© Outofrespect

© Outofrespect

© Outofrespect

© Outofrespect

© Outofrespect

© Outofrespect

© Outofrespect

© Outofrespect

Links to Lizzie

WEBSITE
www.lizziebayliss.co.uk

BLOG
http://lizziecation.blogspot.co.uk/

SOCIAL MEDIA

@lizziebayliss

www.facebook.com/lizziebmodel (modelling)
www.facebook.com/lizziebaylisstog (photography)